WEST OXFORDSHIRE COTSWOLDS

THROUGH TIME

BAMPTON, EYNSHAM, WOODSTOCK, MINSTER LOVELL & SOUTH LEIGH

Stanley C. Jenkins

AMBERLEY PUBLISHING

Acknowledgements

Thanks are due to Michael French, Dino Lemonofides (pps. 23–24) and Hugh Babington Smith (p. 95) for help with the supply of photographs for this book. Other images were obtained from the Lens of Sutton Collection, the Witney & District Museum, and from the author's own collection.

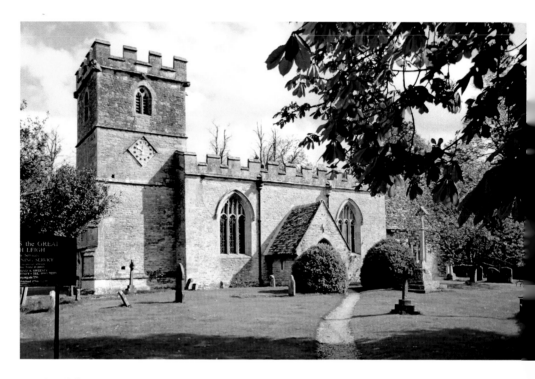

South Leigh
The Church of St James the Great, South Leigh.

First published 2012

Amberley Publishing
The Hill, Stroud
Gloucestershire, GL5 4EP

www.amberley-books.com

Copyright © Stanley C. Jenkins, 2012

The right of Stanley C. Jenkins to be identified as the Author of this work has been asserted in accordance with the Copyrights, Designs and Patents Act 1988.

ISBN 978 1 4456 0996 6

British Library Cataloguing in Publication Data.
A catalogue record for this book is available from the British Library.

Typeset in 9.5pt on 12pt Celeste.
Typesetting by Amberley Publishing.
Printed in the UK.

Introduction

area which we have defined as 'West Oxfordshire' extends from the River Thames in
south to Chipping Norton in the north; in the west, the boundary is delineated by the
ucestershire border, while to the east the Cherwell Valley forms a natural boundary. This
ghly-quadrangular district measures approximately 16 miles from north-to-south and a
ilar distance from east-to-west. The scenery within the area is dictated by the underlying
logy which, generally speaking, consists of a plateau of Oolitic Limestone, with a belt of low-
g Oxford Clay bordering the Thames.

he Oolitic uplands which give the area its distinctive Cotswold character reach a maximum
ation of 810 feet in the vicinity of Chipping Norton, though the hills fall gradually towards
south, where they meet the Oxford claylands. The principal rivers are the Thames,
drush, Evenlode, Glyme and Cherwell, and some of the most attractive scenery is found
g these river valleys.

n ancient times, the area was covered by a dense forest which, in later years, became the
al Forest of Wychwood. Early man was able to penetrate the forest via the river valleys,
le in Romano-British times Akeman Street was constructed through the forest from north-
: to south-west, and thereby facilitated the creation of a network of subsidiary tracks by
ans of which the woodland could be entered.

he end of Roman rule in AD 410 was followed by a period of turmoil in which the
ntryside was colonised by Anglo-Saxon invaders, who subjugated the Britons and imposed
ir language and customs, but never entirely eradicated the Celtic population. The Saxons
n gave their villages topographical names, and it comes as no surprise that woodland
nes are very common. Bampton, for instance, means 'Wood' or 'Beam Town', while names
taining the elements 'ley' or 'leigh' signify woodland clearings. The hamlets of Crawley and
ley, for example, mean the 'Crow Clearing' and 'Hay Clearing' respectively, while North Leigh
obviously the 'North Clearing'.

y the end of the medieval period, the main towns in West Oxfordshire were Witney, Chipping
ton and Woodstock. In the case of Woodstock, urban development had been encouraged
Henry II, who created a new borough near his Royal Palace. Other towns, such as Bampton,
rlbury and Eynsham, seem to have been less successful in attracting urban settlers, but they
e, at least in medieval terms, small townships as opposed to mere villages.

he towns were surrounded by agricultural villages, and there were, in addition, various
lying hamlets on the edges of the towns or at the margins of two or more parishes. The last-
ntioned settlements differed from the main villages, in that they were merely squatter-type
lements with no churches or manor houses at their centres.

n medieval times, the Cotswolds prospered as a result of the wool trade, and many local
rches were enlarged and rebuilt in the Perpendicular style by successful wool merchants
h as John Ashfield of Chipping Norton. Church building ended at the Reformation, and the
ney and effort that had earlier been lavished on religious buildings was then expended on
ular architecture. From about 1530 onwards towns and villages such as Bampton, Eynsham
l Woodstock were extensively rebuilt in Cotswold stone, with two, or even three-storey

buildings in a cohesive architectural style which derived visual unity from the employment local building materials.

About 40 per cent of the available land in Oxfordshire was still farmed on the tradito 'open field' system at the beginning of the eighteenth century. Most of this land was 'enclos during the following decades, with the result that the landscape assumed its familiar mode appearance, with a patchwork of fields and neat farmsteads.

The Victorian era was a period of unprecedented change in which West Oxfordshire w transformed. In particular, the construction of railways such as the Oxford Worcester Wolverhampton line, which was completed on 4 June 1853, represented a feat of engineeri that far exceeded anything that had gone before.

In 1801 Oxfordshire as a whole had a population of 111,977, whereas in 1901 the lo population had grown to 181,120. Most of this growth had taken place in Oxford itself, and the had been a decrease in the population of the rural districts. The smaller towns had more or le static populations, Bampton and Charlbury having populations of 1,167 and 1,352 respectiv in 1901, while Eynsham was slightly bigger, with 1,757 inhabitants.

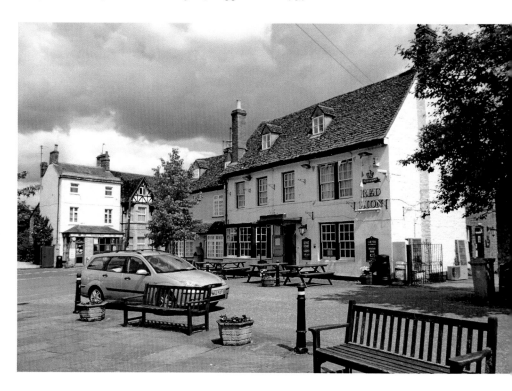

Eynsham
The Square, in Eynsham, with the Red Lion to the right of the picture.

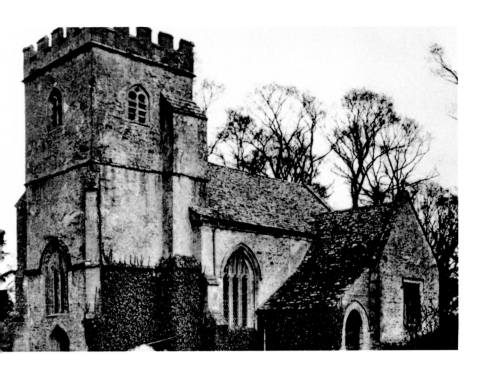

Alvescot: St Peter's Church

Alvescot is a small village, situated in somewhat flat meadowland about two miles to the north-west of Bampton. Its cruciform church was remodelled during the fifteenth century in the Perpendicular style, with an embattled west tower. The village contains many pleasant, Cotswold-style buildings, but the railway station, opened on 15 January 1873, was closed on 16 June 1962. The upper picture is a postcard view of St Peter's Church, probably c. 1912, while the colour photograph was taken 100 years later.

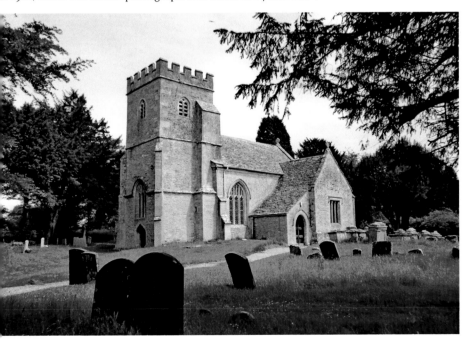

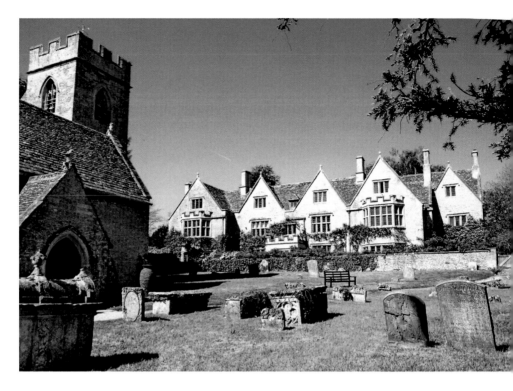

Astall: The Church & Manor House

Nestling in the picturesque Windrush Valley between Witney and Burford, Astall is on the route of Akeman Street, and Roman remains have been discovered near the present village. The Parish Church of St Nicholas incorporates transitional Norman work of *c.* 1160, while the neighbouring Jacobean manor house was built by Sir William Jones. Other features of interest include a Saxon burial mound, and a former woollen mill at Worsham Bottom (*below*), which was used mainly for spinning yarn.

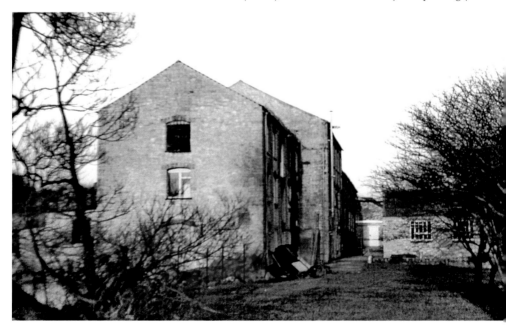

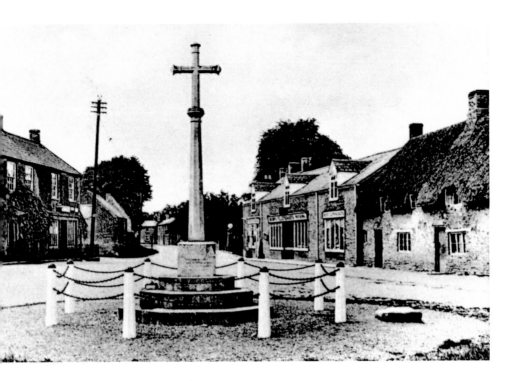

Aston: The Square & War Memorial

The name Aston signifies 'East-Town' – Aston having originated as an outlying hamlet of nearby Bampton, some 3½ miles to the west. Aston and Bampton are both situated on a belt of Oxford Clay, 'a region of meadowland and waving grass, with the slow and solitary Thames winding through it, of stone-built villages gracefully-embowered in trees, and of fine churches – a beautiful landscape in May and June'. *Above*: the Square *c.* 1930. *Below*: The Square in 2012.

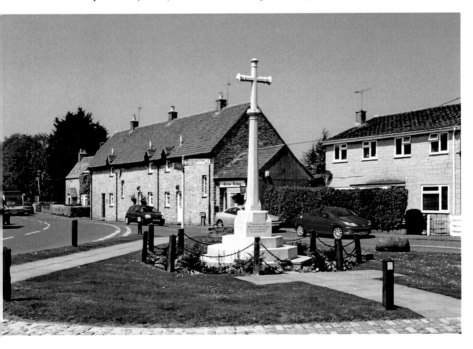

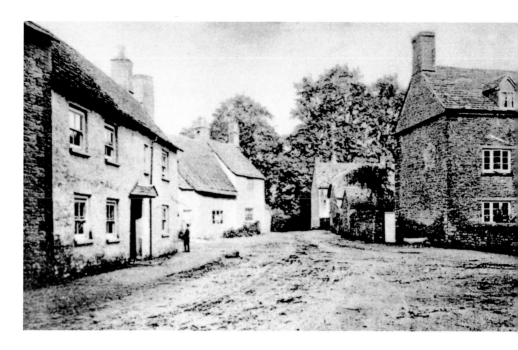

Aston: Vernacular Buildings

Aston contains many interesting old buildings such as these in Bampton Road. External walls are formed of random rubble, while window and door apertures incorporate wooden lintels which bear the weight of the stonework above. This form of construction is very common throughout West Oxfordshire, whereas in other parts of the Cotswolds the buildings often have mullioned windows with stone drip-moulds; the absence of mullions may indicate a later period of construction, or it may simply reflect local building traditions.

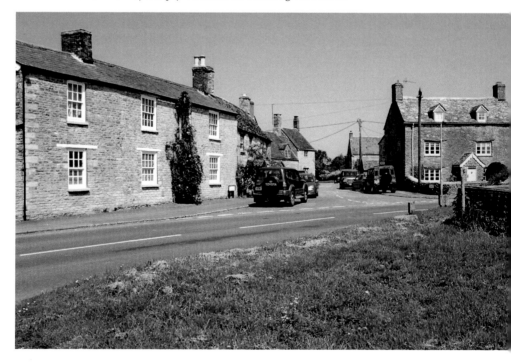

Aston: The Basque Children

Over 20,000 children were evacuated from the Basque Region of northern Spain after the bombing of Guernica during the Spanish Civil War in 1937. Around 4,000 were brought to England and re-located in about seventy residential homes or 'colonies' that had been set up by well-wishers throughout Britain, one of these being in a former children's home at Aston known as 'St Joseph's' (now Westfield House).

The upper photograph shows a group of Basque children walking along Bampton Road, accompanied by local volunteer Phyllis Ransom, the daughter of a Witney chemist, while the lower picture shows Bampton Road in 2012; Aston church can be seen in the distance in both views. Although rural Oxfordshire must have been a haven of peace after the horrors of the Spanish Civil War, there was a mood of underlying sadness – some of the children having lost all contact with their families, while two sisters received the news that their father had been shot dead on his doorstop in front of their mother.

St Josephs remained in use until October 1939, and during that time it relied on the goodwill and support of local people and Oxford undergraduates such as Cora Portillo (*née* Blyth), who was then a modern languages student at St Hilda's, and had volunteered to teach English to the Basque children at weekends. She later married Luis Gabriel Portillo (1907–93), a young university lecturer who had fled from Spain in February 1939, and was also helping in the Basque colonies as a teacher.

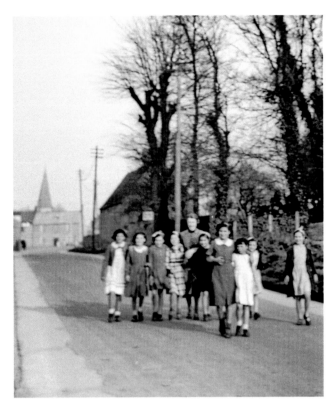

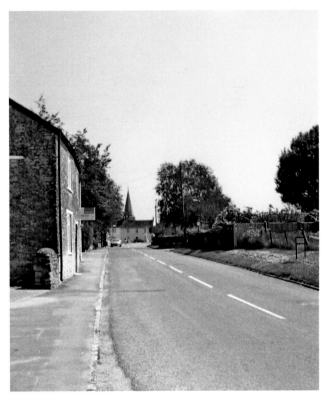

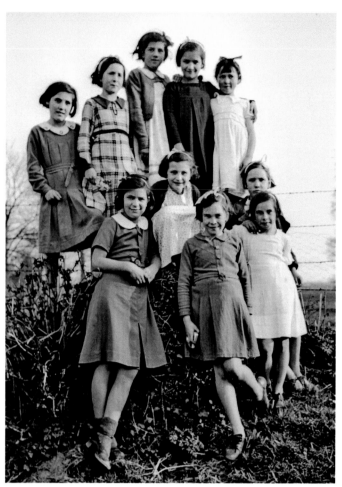

Aston: The Basque Children

(Above) A group of ten Basque children from the Aston colony, photographed by Phyllis Ransom *c.* 1938.

(Below) On Thursday 17 July 2003 a blue plaque was unveiled at Westfield House to commemorate the use of the building as a temporary home for the Basque refugee children between 1937 and 1939. The plaque was provided by Oxfordshire Blue Plaque Board and commissioned by the Basque Children of '37 Association. The plaque was unveiled by Cora Portillo, and several of the former 'Basque children' attended the ceremony, together with Cora's son, the writer, broadcaster and politician Michael Portillo, who can be seen standing fourth from the right in the back row.

Inset: The blue plaque on Westfield House.

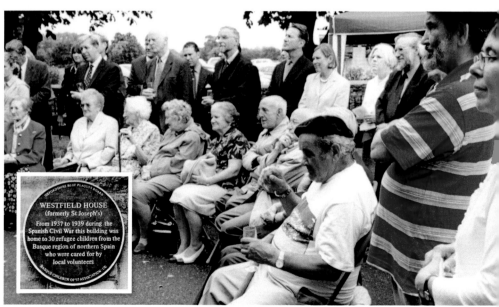

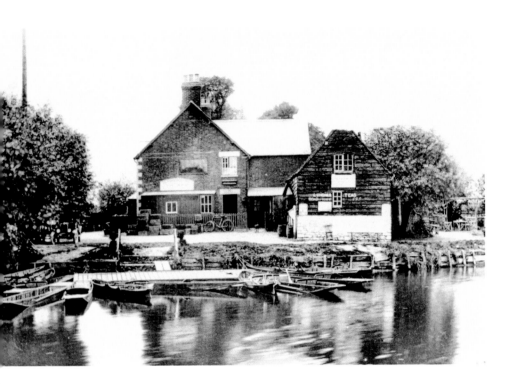

Bablockhythe: The Ferryman

The Upper Thames flows along the southern edge of the Oxfordshire Cotswold district, passing Kelmscot, Radcot, Newbridge and Eynsham. This part of the river was known as 'The Isis' in university circles, and even today Ordnance Survey maps refer to the 'Thames or Isis'. Bablockhythe, some 11 miles 4 chains upstream from Oxford, was once the site of a chain ferry and, although this quaint feature has disappeared, a pedestrian ferry still operates sporadically at the Ferryman Inn.

Inset: The Ferryman Inn in 2012.

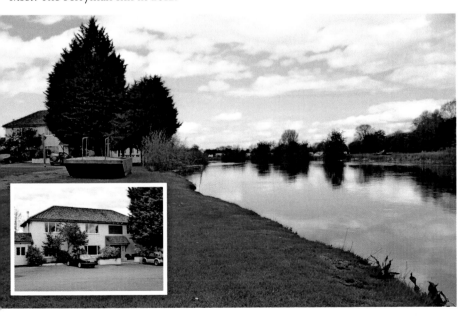

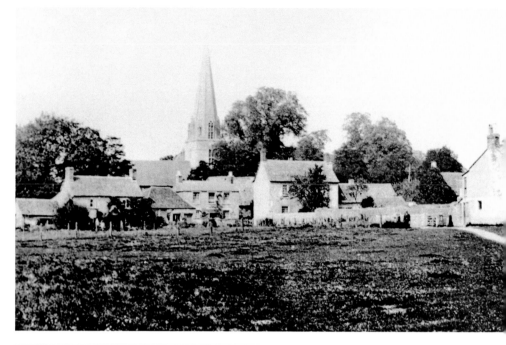

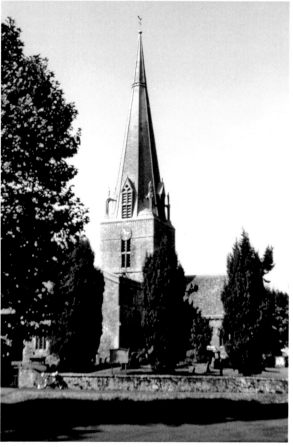

Bampton: St Mary's Church
The Domesday Survey of 1086 reveals that Oxfordshire was one of the most prosperous counties in England, and Bampton – a royal manor – was the largest settlement in the area, its population of about 500 being at least twice that of neighbouring Witney. Bampton church, one of the most impressive parish churches in Oxfordshire, incorporates a considerable amount of Norman fabric, while the massive tower, which contains some 'herring bone' stonework, typical of the eleventh century, may have a Saxon core. The aisles, transepts, a new nave and the octagonal spire were added during the thirteenth–fourteenth centuries, while at the same time the original nave was replaced by the present chancel. The lower view was taken from Church Street, while the earlier view provides a glimpse of the church from the nearby fields.

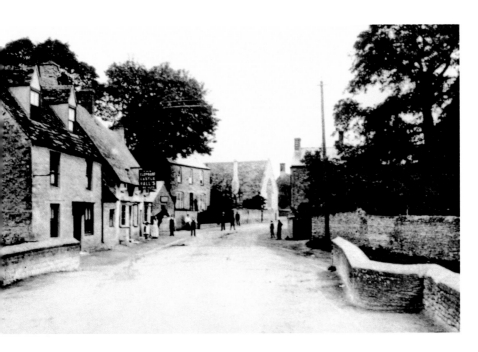

Bampton: Bridge Street

Bridge Street, Cheapside and Broad Street, which now form part of the A4095 road, constitute Bampton's main thoroughfare, whereas the High Street, which diverges to the east, is merely a 'B' road. The upper picture shows Bridge Street, *c.* 1912, looking east towards the Market Square, with the parapets of the bridge visible in the foreground; the bridge spans a small stream known as the Shill Brook. The Elephant & Castle pub, seen in the upper photograph, is now a private house.

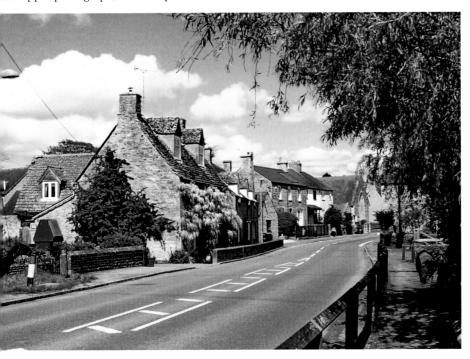

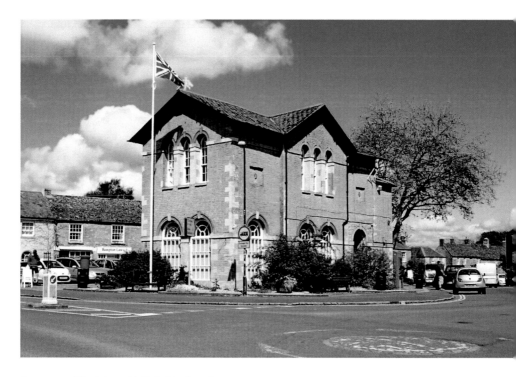

Bampton: The Town Hall & Market Square

Situated at the junction of Bridge Street, Cheapside and High Street, Market Square is regarded as the centre of Bampton. The substantial, Italianate Town Hall, erected *c.* 1838, was designed by George Wilkinson (1813–90) of Witney, a prolific local architect who subsequently became architect to the Poor Law Commissioners. In this capacity he designed numerous workhouses throughout England, Ireland and Wales, together with several Irish railway stations, including those at Sligo, Mullingar and Longford on the Midland Great Western Railway.

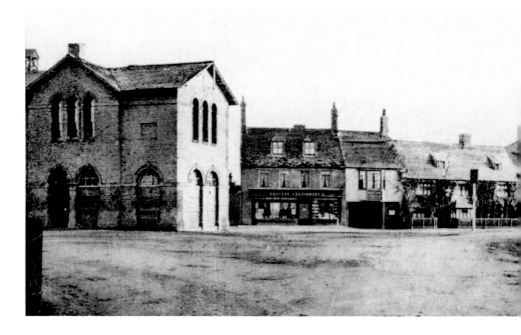

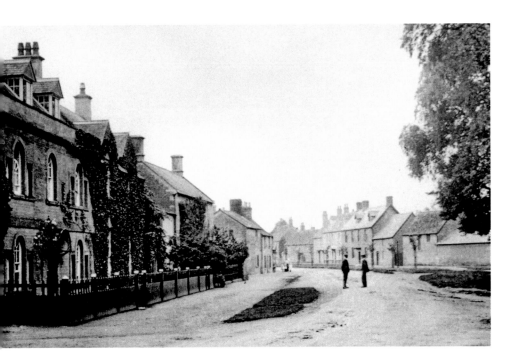

Bampton: Broad Street

Broad Street is, in effect, a northwards continuation of Cheapside and, like other parts of Bampton, it is replete with venerable Cotswold stone buildings. The upper view, looking south towards Cheapside and the Market Square, is of *c.* 1912, while the colour photograph was taken in 2012. The large Georgian house which is visible to the left in both photographs is known as 'The Elms', and it boasts four elegant Venetian windows and a central doorway with a boldly-arched stone hood.

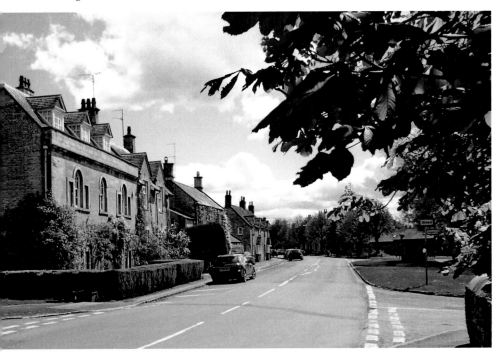

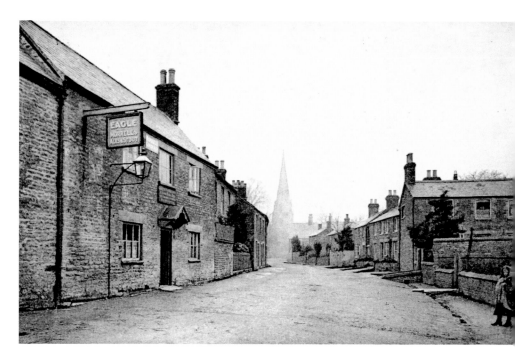

Bampton: Church View & The Eagle

Church View, extending northwards from Bridge Street, is a picturesque backstreet. The Eagle, seen on the left in the upper photograph, is another defunct pub. There were, at one time, up to a dozen pubs in Bampton, including the Elephant & Castle, the New Inn, the Swan, the Bell, the Fish, the George & Dragon, the Mason's Arms and the Fleur-de-Lys. Today there are just four: the Talbot, the Horse Shoe, the Romany Inn and the Morris Clown.

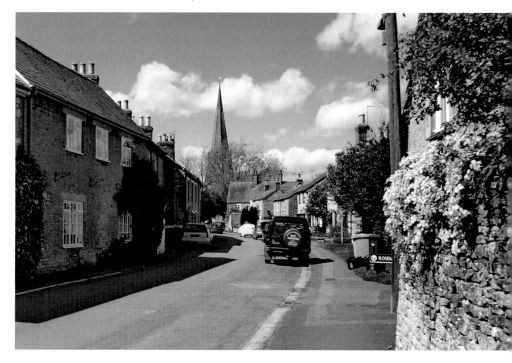

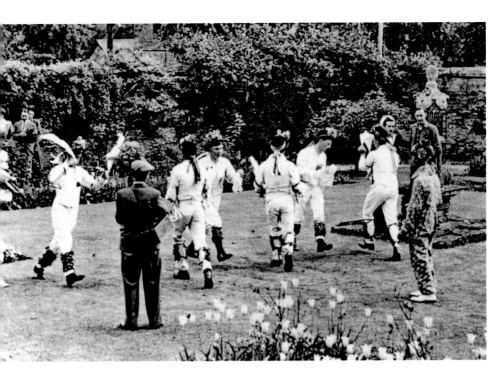

Bampton: Morris Dancers & the Morris Clown

Bampton is famous as the 'cradle of Morris dancing', old traditions having survived for centuries in this relatively-isolated place. The upper picture shows the local Morris 'team' in action at Weald Manor, possibly *c.* 1939. There are, at present, three Morris teams in Bampton, each with its own clown or 'squire' – a grotesque figure who belabours the dancers with an inflated pig's bladder. The former New Inn, in the High Street (*below*), is now called the Morris Clown.

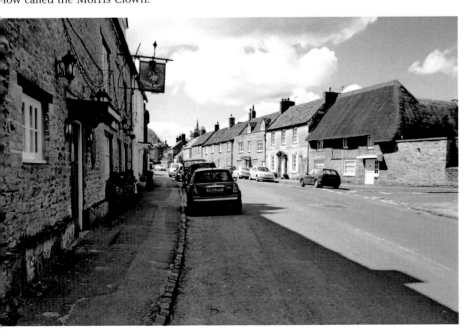

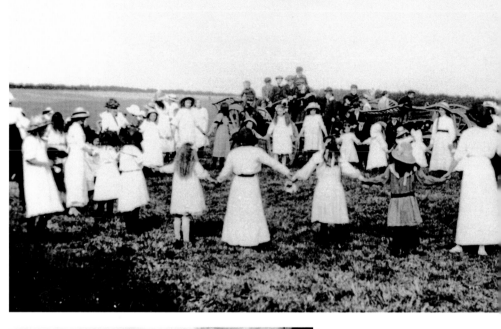

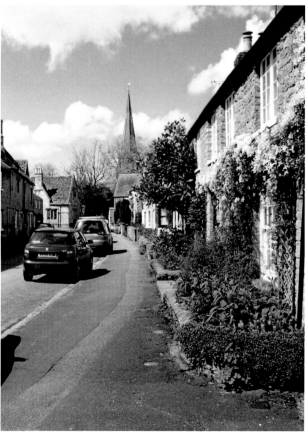

Bampton: Village Dance & Song
At first glance, the upper picture would appear to show part of a 'club feast' and, as such, it recalls the club-walking scene in Chapter Two of Thomas Hardy's great tragic novel, *Tess of the d'Urbervilles*. However, the presence of a Union Flag on one of the farm wagons suggests that the occasion may have been a national event such as Queen Victoria's Diamond Jubilee or, perhaps more likely, the Coronation of King George V in 1911. One of the farm wagons visible in the picture belongs to a G. E. Gerring who, according to the 1911 *Kelly's Directory of Oxfordshire*, was a farmer based in Broad Street.

The final picture of Bampton (*below*) provides a further glimpse of Church View, looking north, with a row of Cotswold-style cottages to the left and the old grammar school visible in the distance; the latter building is now the public library.

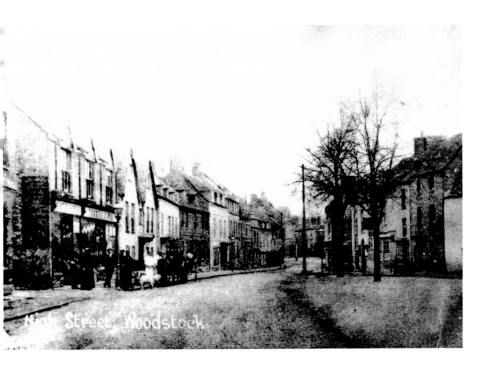

Blenheim & Woodstock: The High Street

Woodstock was a royal manor in Saxon times while, after the Norman Conquest, Henry I built a new royal palace and enclosed a 'park'. Urban development was further encouraged by Henry II, who laid-out a new settlement on the south side of the River Glyme. The upper view shows the High Street, looking west *c.* 1912, while the colour photograph, taken a century later, shows the same street, albeit from a slightly different vantage point, about 100 yards to the east.

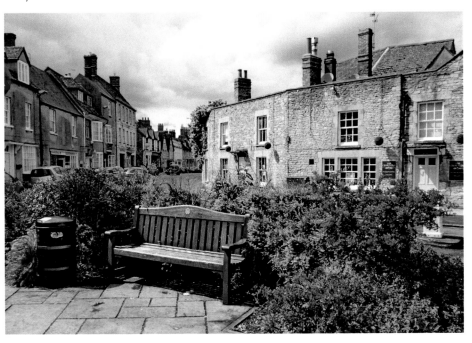

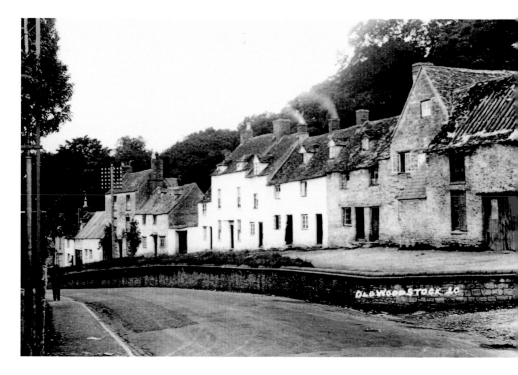

Blenheim & Woodstock: Old Woodstock

Old Woodstock, on the north side of the River Glyme, was the original village settlement, whereas 'new' Woodstock, to the south of the river, was Henry II's medieval new town. The neighbouring royal palace contained a great hall, a chapel, walled gardens and at least one large courtyard. The building was damaged during the Civil War and its remains were cleared away around 1710, by which time Blenheim Palace was taking shape in another part of the former royal park.

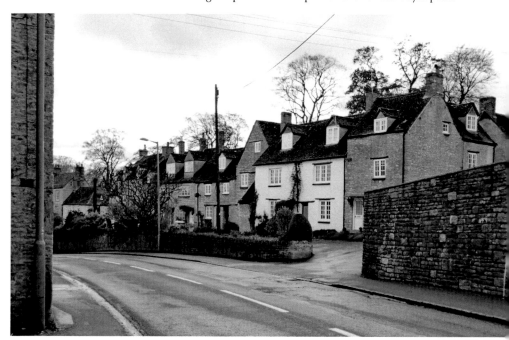

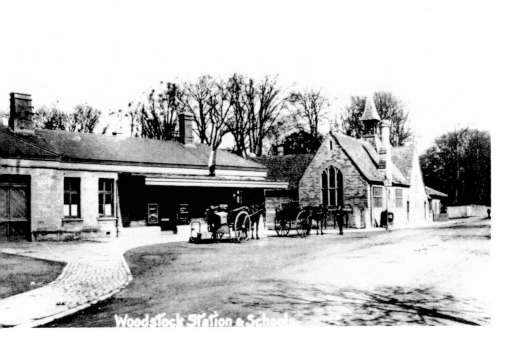

Woodstock Station & Schools

Blenheim & Woodstock: The Railway Station

Blenheim & Woodstock station was constructed by the Woodstock Railway Company, and opened on Monday 19 May 1890. The railway had been financed largely by the Duke of Marlborough, but it was worked from its inception by the Great Western Railway, which purchased the line outright in 1897. Blenheim & Woodstock station was closed in 1954, and the terminal building subsequently became a garage, as shown in the lower illustration. The building has latterly been adapted for residential use.

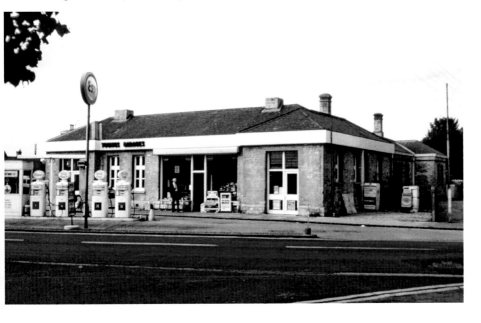

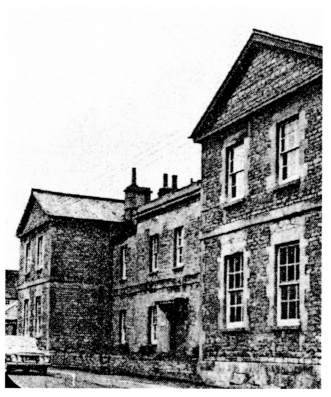

Blenheim & Woodstock: The Workhouse

Woodstock Workhouse, which was built in 1837 at a contract price of £3,100, was sited on the north side of Hensington Road. It was designed by George Wilkinson of Witney, and could accommodate up to 300 paupers, who were housed in separate wings according to their age and gender – an attempt being made to distinguish the 'deserving poor' (such as old people and orphans) from idle and feckless persons who simply refused to find work. An infirmary was added in 1891, while a chapel was erected immediately to the east of the main block, all of these buildings being substantially-constructed of local stone.

Speaking many years later, Mrs Agnes Dandridge, a former child inmate recalled: 'We used to have to wear a red frock and white pinafore, black boots and stockings. We used to have to get up at seven, and we had bread and margarine and cocoa for breakfast, and on Saturday always for dinner bread and cheese and a big mug of cocoa. We used to have a bath on Saturday mornings.'

The Workhouse later became an old peoples' home known as Hensington House but, sadly, this impressive Victorian building was demolished in 1969, the site being cleared to make way for a library, fire station and car park. The upper picture shows the street frontage of the workhouse prior to its destruction, while the colour photograph shows the accretion of decidedly-undistinguished buildings that have replaced it.

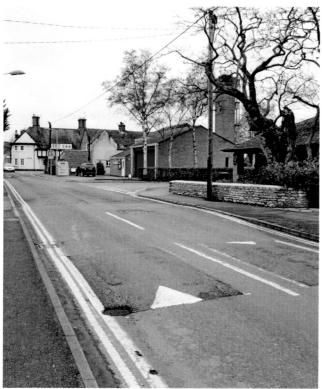

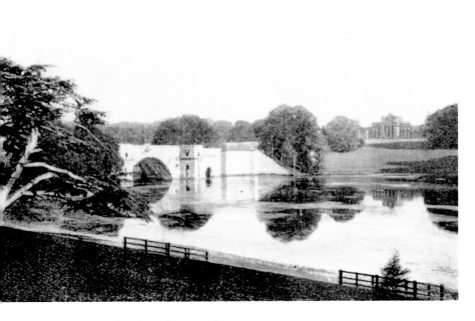

Blenheim & Woodstock: The Palace & Lake

Blenheim Palace and its surrounding estate was conferred on John Churchill, Duke of Marlborough, as a reward for his victory over the French at the Battle of Blenheim in 1704. This huge Baroque building was designed by John Vanbrugh (1664–1726) and Nicholas Hawksmoor (1661–1736), and completed in the 1720s. Winston Churchill was born at Blenheim on 30 November 1874. The upper view shows the palace from the lake, while the lower photograph shows part of the grandiose North Front.

Inset: A glimpse of the East Front, with the Kitchen Court visible in the background.

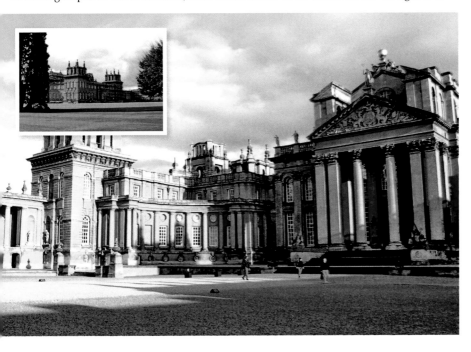

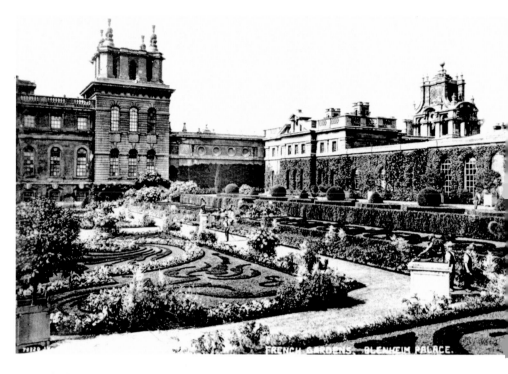

Blenheim & Woodstock: The Palace

An Edwardian postcard view of the French Garden at Blenheim (*above*). This *c.* 1910 scene shows merely a fragment of the huge palace which was, for much of its life, a controversial structure. Writing in the 1906 *Little Guide to Oxfordshire*, John Brabant called it 'heavy and ungraceful', though he admitted that it had a 'massive dignity'. Only in modern times has its true grandeur gained critical acceptance, and Blenheim Palace is now one of Oxfordshire's leading tourist attractions. *Below*: The Kitchen Court from the west.

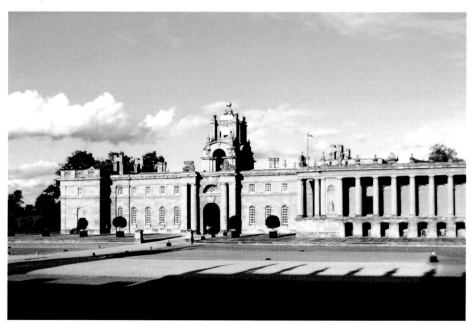

Brize Norton Village & Aerodrome

Until 1936, Brize Norton was merely a small village, but in that year the Air Ministry began construction of a military aerodrome, which would later become famous as RAF Brize Norton. Opened on 13 August 1937, the airfield was built as part of the so-called 'Expansion Plan' that produced eighty-nine new aerodromes between 1935 and 1939. By 1940 the school had been re-equipped with Airspeed Oxfords, and on 16 August 1940, forty-six of these twin-engined trainers were destroyed in an air raid. A few months later, on 10 April 1941, the Germans raided the airfield again – this time causing only minor damage. Later in the war, Brize Norton became involved with glider training, and in the period leading up to D-Day Whitley and Albemarle bombers could be seen towing Horsa Gliders in the skies above West Oxfordshire. In March 1944 the station became the home of Nos. 296 and 297 Squadrons, both of which participated in the D-Day and Arnhem operations, using Albemarles and Horsas on each occasion.

Brize Norton became an American 'Base' after the Second World War, its runways being extended to accommodate large jet aircraft such as the B-47s. The Americans left in April 1965, and the airfield reverted to RAF control. Aircraft seen at the station in the 1960s and early 1970s included Belfasts and VC10s, while in 1982 the VC10 fleet played an important part in the Falklands campaign.

The upper picture provides a general view of Brize Norton village, looking along Station Road around 1912, long before the construction of the aerodrome, while the colour view was taken in 2012, looking eastwards along Carterton Road.

Inset: A C-130 Hercules transport aircraft.

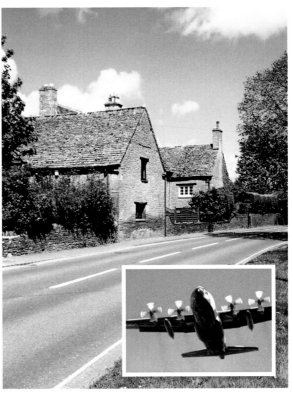

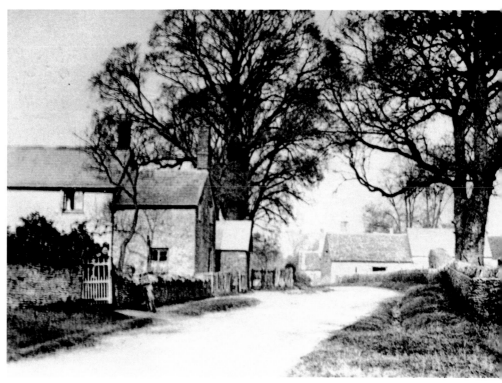

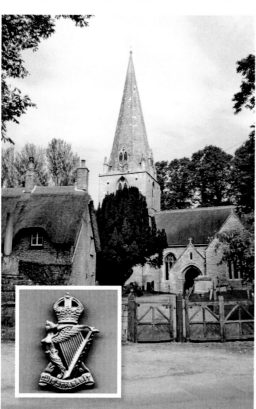

Broadwell: The Church of St Peter & St Paul

Like Brize Norton, the village of Broadwell, four miles to the west of Bampton, gave its name to a Second World War aerodrome, which was actually much nearer the adjoining village of Kencot! Opened in 1943, RAF Broadwell was used primarily by Dakotas of Nos. 512 and 575 Squadrons, which participated the in the D-Day invasion by conveying the 8th and 9th Parachute Regiments and the 1st Battalion Royal Ulster Rifles to Normandy – the Ulsters being carried in Horsa gliders.

The airfield was closed after the war, and Broadwell is today a quiet place, with Cotswold stone cottages and an impressive parish church. The manor house was burned down long ago, leaving just two tall gate pillars beside the village street. The parish church, dedicated to SS. Peter & Paul, is mainly Norman, although the transepts and impressive spire were added in the thirteenth century.

Inset: The cap badge of the Royal Ulster Rifles, who were accommodated in a camp at Broadwell prior to D-Day in June 1944.

Burford: Old Buildings in the High Street

One of the most attractive small towns in Oxfordshire, Burford consists mainly of one long street which climbs steeply from the Windrush Bridge, with side streets such as Sheep Street and Witney Street extending to the west and eastwards respectively. There are many picturesque old buildings, most of these being constructed of Cotswold stone, though there is some exposed timber-framing as shown in the lower illustration. The parish church, with its memories of the Levellers, is sited near the river, while Burford Priory has further associations with the Civil War in that it was the home of William Lenthall (1591–1662), the Speaker of the Long Parliament who famously defied King Charles I in 1642.

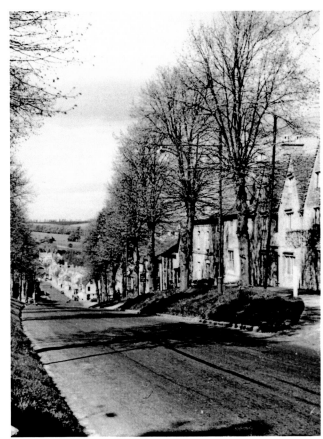

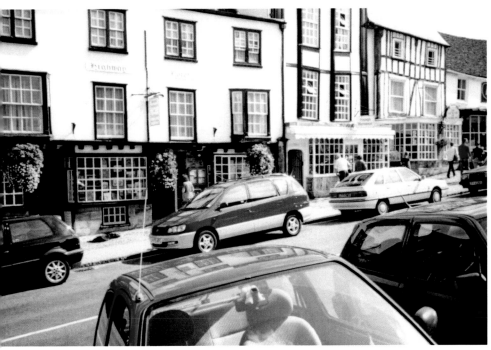

27

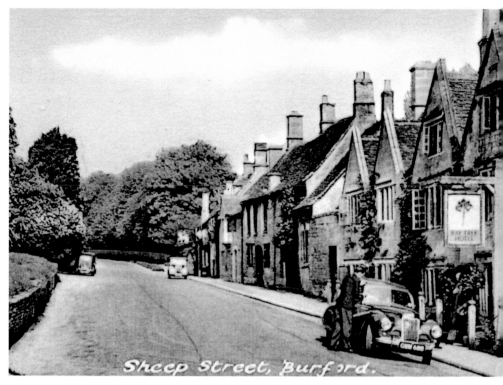

Sheep Street, Burford.

Burford: Old Buildings in Sheep Street & Witney Street

The upper view provides a glimpse of Sheep Street, as depicted in a *c.* 1950s postcard, while the more recent photograph shows the aptly-named Great House in Witney Street – a monumental seventeenth-century structure that seems out-of-proportion to its immediate neighbours. This distinctive building was said to have been the home of Robert Fettiplace, whose family lived at nearby Swinbrook. Further details of Burford, and its interesting buildings, can be found in a companion volume, *Burford Through Time*, by Raymond Moody.

Carterton: William Carter's Utopian Community

Carterton is a modern settlement that developed in the years before the First World War when William Carter, the Chairman of a company known as 'Homesteads Ltd', purchased a 740-acre site from the Duke of Marlborough and sub-divided it into 350 smallholdings for sale to the public for as little as £20 per acre. Contemporary sales documents described the 'excellent arable grass and water meadow land, in a high state of cultivation', which would be 'suitable for market gardeners, dairymen, poultry keepers, apiarists, horticulturalists and others', while bungalows 'of excellent construction' with tiled roofs and two acres of land were also advertised.

The scheme was a curious mixture of utopian ideals and commercial reality but, at a time when issues such as public health, unemployment and excessive emigration were becoming increasingly important, the Carterton venture attracted many favourable comments. In 1906, for example, Mr E. N. Bennett MP opined that Carterton was an excellent object lesson for land reformers; each man worked his own plot of land and market-gardening was flourishing: 'Thousands of fruit trees are being planted in the open and there are no unemployed at Carterton. Everyone is busy in his own line and the only grumbler is the resident doctor, who declares that Carterton is too healthy a place for his profession.'

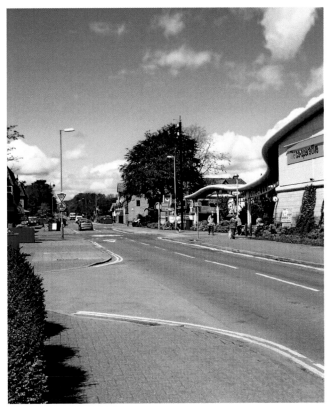

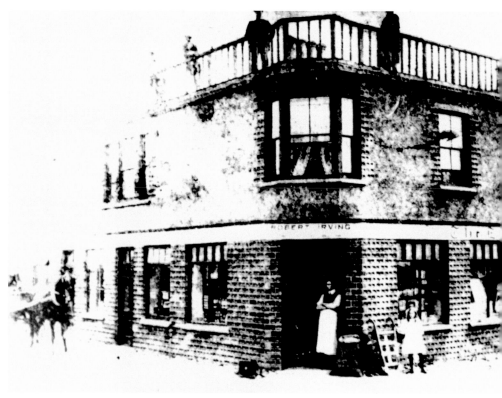

Carterton: 'The Emporium'

The facilities provided at Carterton during the early years included a 'park', and sites were laid out for Anglican and Methodist places of worship, although the railway station was not opened until 2 October 1944.

A post office and two shops appeared on either side of the crossroads at the centre of the community, one of these being a colonial-style general store known as 'The Emporium', which is shown in the upper picture. This substantial two-storey building later became a popular pub known as The Aviator, but it has latterly been renamed The Golden Eagle, as shown in the lower illustration (the other shop is shown on p. 29).

In the Post-Second World War era, when RAF Brize Norton was used by the US air force, Carterton acquired a distinctly 'Mid Western' atmosphere, which was accentuated by its American type 'grid iron' street plan and single-storey dwellings.

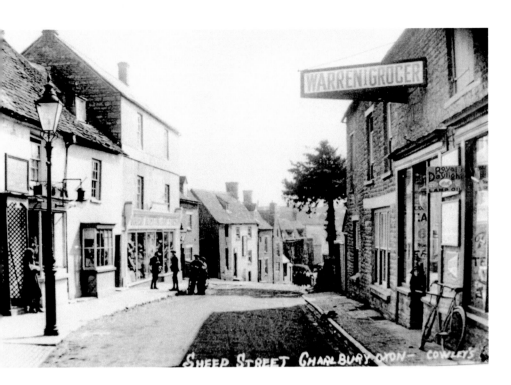

Charlbury: Sheep Street

In contrast to Carterton, Charlbury is a very ancient place that was granted by the King of Mercia to the Bishop of Lincoln, and eventually passed, by exchange, to the monks of Eynsham Abbey. The old town consists of a maze of narrow streets on a hill-top site above the River Evenlode, the main street being Sheep Street, which merges into Market Street at one end and Hixet Wood at the other – the three streets forming one continuous thoroughfare.

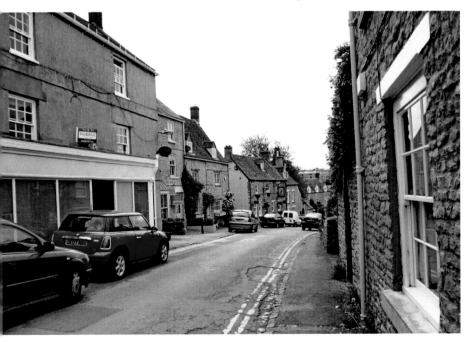

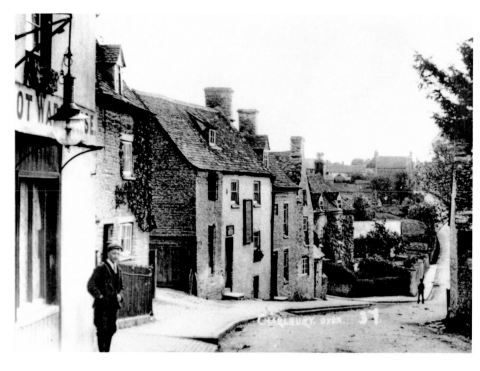

Charlbury: Sheep Street

The upper view depicts Sheep Street, looking south towards Hixet Wood *c.* 1912, while the lower view was taken from a similar vantage point in 2012. The pub – now known as Ye Olde Three Horse Shoes – features prominently in both views. Pooles Lane runs parallel to Sheep Street, the two streets being linked by lanes and alley-ways such as Brown's Lane and Fisher's Lane, which thereby form a veritable warren of narrow streets in the centre of Charlbury.

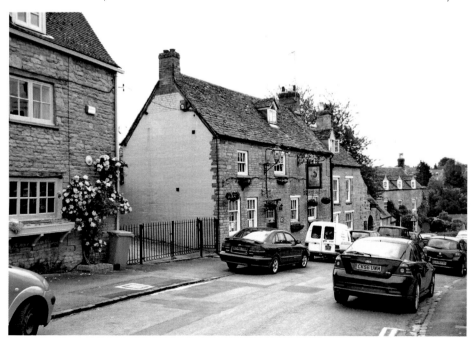

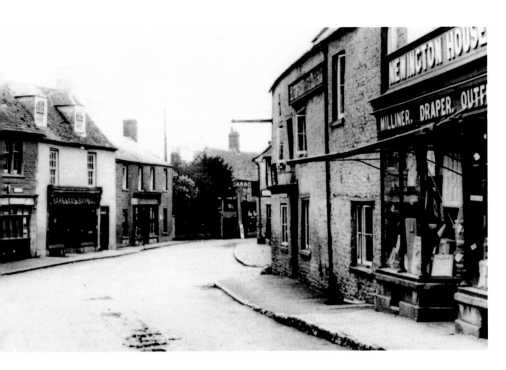

Charlbury: Junction of Market Street & Dyer's Hill

At its northern end, Market Street continues north-westwards as Thames Street and Pound Hill, while another road, known as Dyers Hill, runs west towards the railway station. The upper view shows this busy road junction *c.* 1920, whereas the lower view was taken from Market Street in 2012. Despite the introduction of one-way systems and double-yellow lines, Charlbury has considerable traffic problems – particularly during the morning and evening peak periods, when commuters' cars are heading to or from the station.

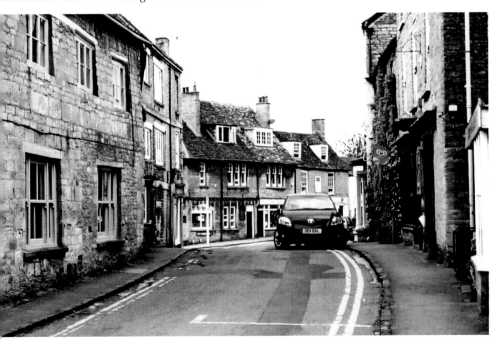

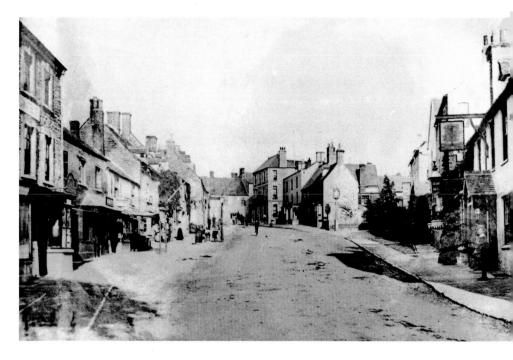

Charlbury: Church Street

Church Street, which runs westwards from Sheep Street towards St Mary's Church, is somewhat wider than Charlbury's other streets, and it contains several attractive buildings, most of which are of eighteenth-century origin. Charlbury itself has a long, but largely uneventful history, although it can claim to have been the birthplace of Anne Downer (1624–86), one of the vicar's daughters, who became a Quaker and is said to have been the first woman to preach to the public in London.

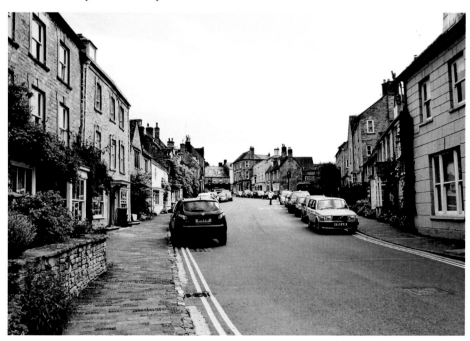

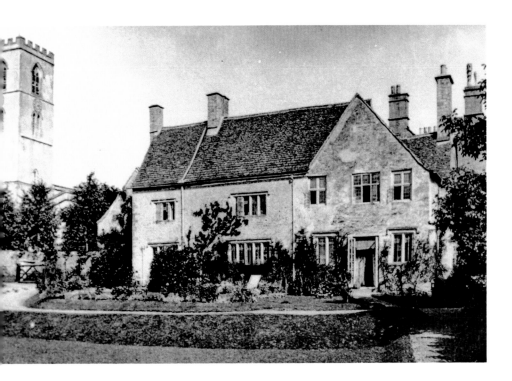

Charlbury: St Mary's Church

The parish church of St Mary contains several Norman features, including a north arcade with round arches, although the building was enlarged and much-rebuilt during the thirteenth century, when the embattled west tower was added. The Rectory is of Victorian origin, although the nearby Priory is thought to contain a medieval core. The upper view shows St Mary's Church from the west, while the colour photograph shows the entrance to the churchyard from the bottom end of Church Street.

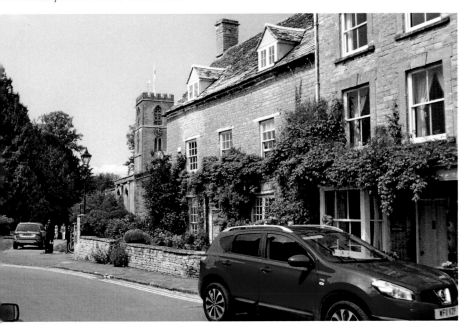

Charlbury: The Brunelian Railway Station

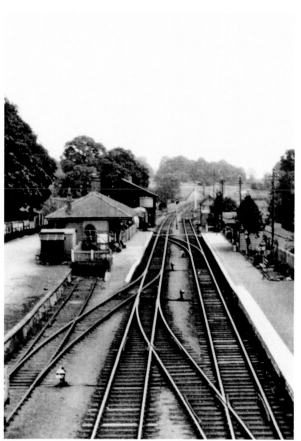

Charlbury station was opened by the Oxford Worcester & Wolverhampton Railway on 4 June 1853, its distinctive Italianate station building having been designed by Isambard Kingdom Brunel (1806–59), although Brunel had resigned from his post as OW&WR engineer before the line was completed.

The building is of timber-framed construction with a hipped, slated roof. As originally built it featured an open-plan booking hall, but the interior of the building was later sub-divided into a separate ticket office and booking hall; the small waiting room at the south end was originally a ladies' waiting room. The station is today a rare example of Victorian prefabrication. The upper photograph, taken c. 1920, shows the goods yard, which remained in use until the withdrawal of goods facilities in November 1970.

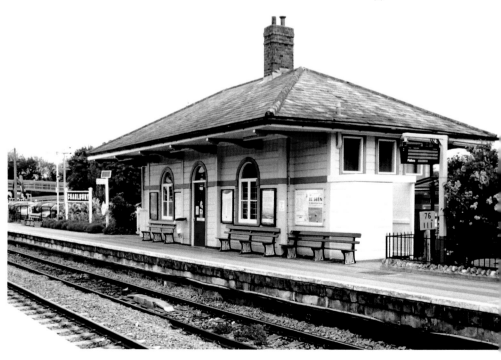

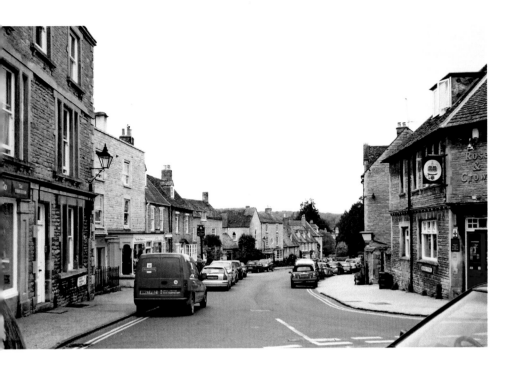

Charlbury: Street Scenes

Two additional views of Charlbury; the upper photograph shows Church Street, looking west towards the church, while the lower view illustrates some picturesque old Cotswold stone houses in Pooles Lane, in the very centre of Charlbury. The footpath that can be seen in front of the houses provides a pedestrian link to Bayliss Yard which, in turn, leads into Sheep Street.

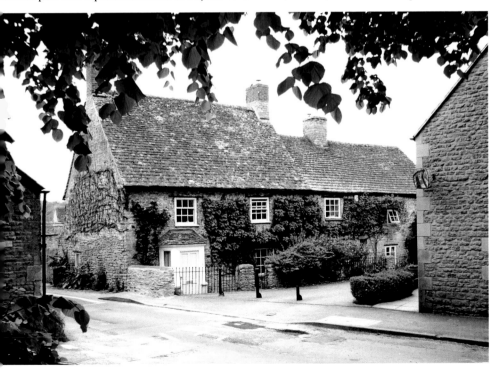

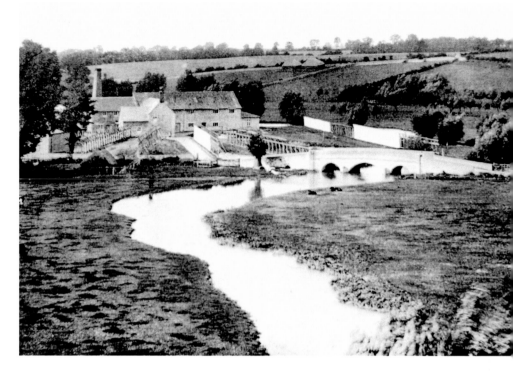

Crawley: The Blanket Mill

Crawley, a small hamlet to the north-west of Witney, was the site of a woollen mill that was used by Smiths Blankets for fulling, bleaching, dyeing and other blanket-making operations. The oldest part of the mill (*above*) was a two-storey Cotswold stone structure with a small, square chimney stack, while a larger, later mill with a cylindrical brick chimney stack was situated to the south of the original Cotswold stone building. The site has now been divided into small industrial units.

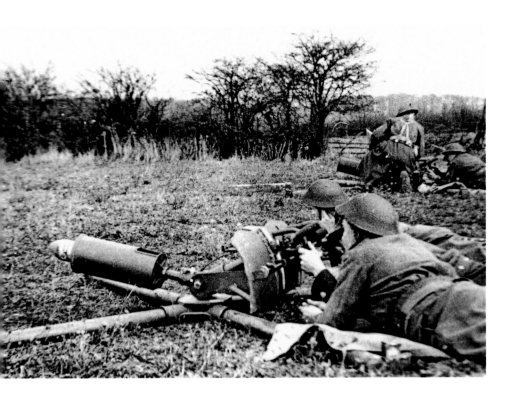

Crawley: Wartime Activities

The 3rd Battalion, Oxfordshire Home Guard, had an improvised 'training ground' at Crawley during the Second World War, and the upper photograph shows the Witney Platoon firing a 'Blacker Bombard'. In June 1940 an aerodrome known as 'RAF Akeman Street' was opened on a site immediately to the north of the hamlet as a Relief Landing Ground for RAF Brize Norton, but these wartime activities are long-forgotten, and Crawley is now a tranquil rural community, as exemplified by the colour photograph.

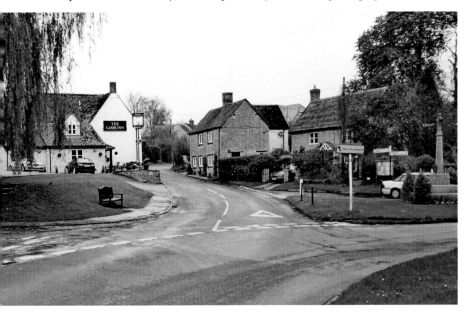

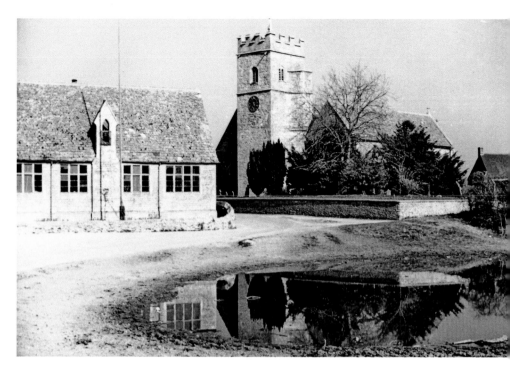

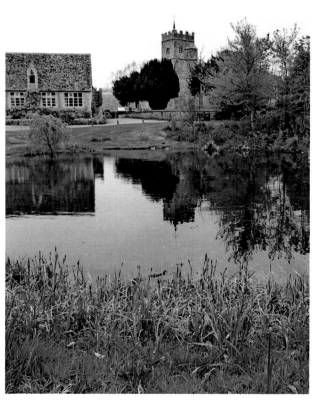

Ducklington: The Church & National School

Ducklington is a small village on the River Windrush, about one mile to the south of Witney, and now virtually joined to it by ribbon development along the Witney road. The village is mentioned in an Anglo-Saxon charter of *c.* 958, whereby 'Duclingtun' was granted by King Edgar to a landowner called Eanulf. The Domesday survey of 1086 suggests that the village had a population of around 150 by that time.

St Bartholomew's Church, which contains evidence of Norman work, is surrounded by picturesque stone cottages with thatched roofs, this idyllic scene being further enhanced by the presence of a traditional village pond. The National (i.e. Anglican) School, to the left of the parish church, was built *c.* 1858.

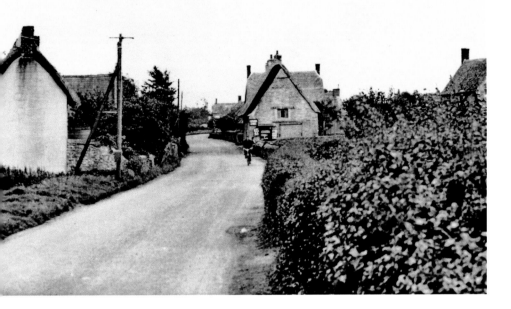

Ducklington: Witney Road

The upper view shows Witney Road, looking south-east towards the church, probably c. 1930s, while the lower view was taken around eighty years later. The road has been straightened, pavements have appeared, and the slightly-decrepit cottages seen in the earlier picture have been repaired but, otherwise, little seems to have changed in this part of Ducklington, although many new houses have been erected in other parts of the village.

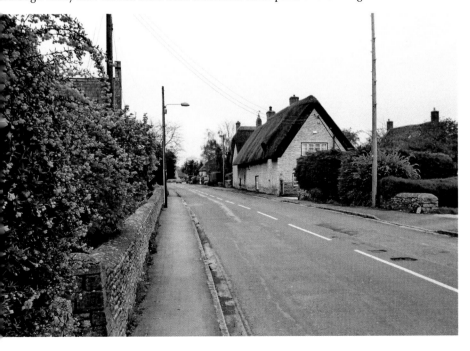

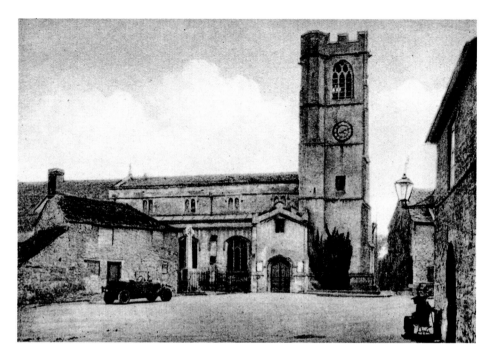

Eynsham: The Square

Eynsham, the only Oxfordshire town on the Upper Thames, was formerly a place of considerable importance, being the site of a major Benedictine Abbey which had been founded in 1005 and re-founded after the Norman Conquest. The parish church was sited just outside the Abbey gates, the open space in the foreground forming a tiny 'Market Square', as shown in the lower illustration. Eynsham Abbey was surrendered in 1539, and the last abbot, Anthony Kitchen, was made Bishop of Llandaff.

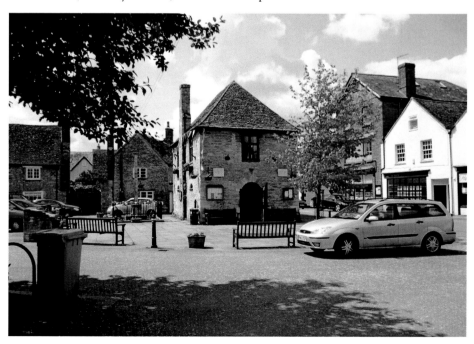

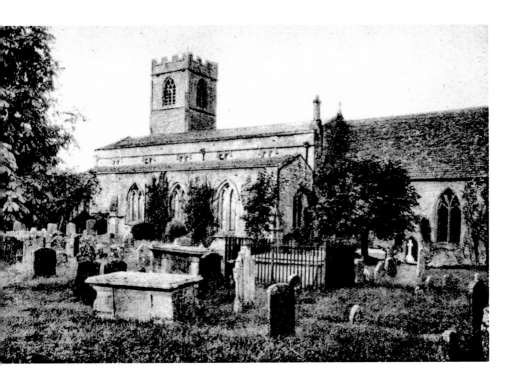

Eynsham: St Leonard's Church

St Leonard's Church, on the south side of the Square, incorporates a thirteenth-century chancel and south aisle, though other parts of the fabric, including the north aisle, clerestory, porch and north-west tower, are additions of *c.* 1450 in the Perpendicular style. Although the neighbouring Abbey was dismantled after the Reformation, the ruins of its west front were still standing in the seventeenth century, but these fragmentary remains were subsequently demolished, and the great abbey has now disappeared in its entirety.

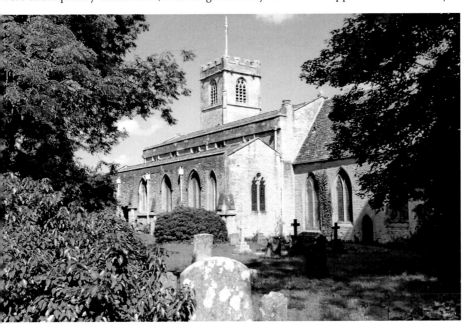

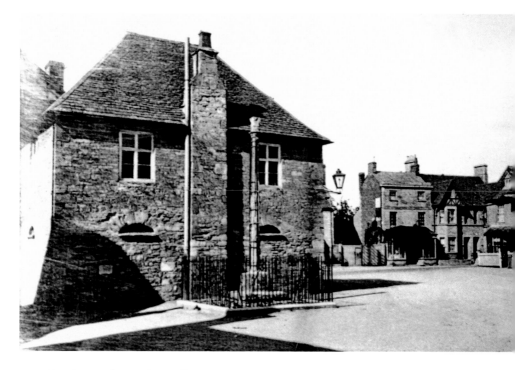

Eynsham: The Market Hall

A *c.* 1912 postcard view showing the Square, with the seventeenth-century Market Hall prominent to the left of the picture. This quaint old hipped-roofed building was built to house a court house and John Bartholomew's charity school. It originally featured an open loggia on the ground floor, but this was enclosed during the nineteenth century to create a gaol. The neighbouring market cross, which probably dates from the fourteenth century, was reinforced with iron strapping by a local blacksmith.

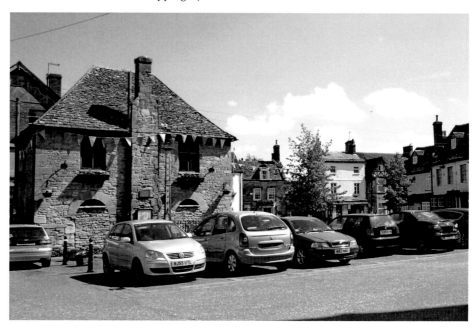

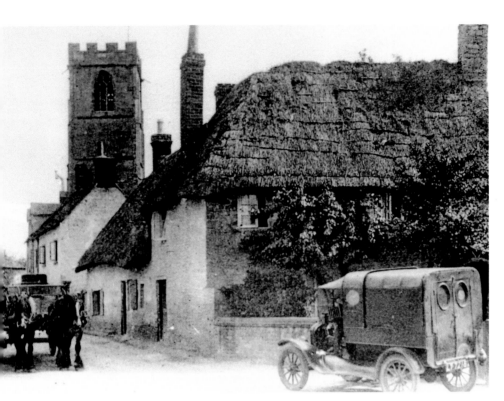

Eynsham: Swan Street

Two views of Swan Street, looking east towards St Leonard's Church, the upper view dating from *c.* 1920, whereas the colour view was taken in 2012. The thatched cottages have lost their rendering, but otherwise surprisingly little has changed in this quiet side street, which forms a short-cut between the Square and Station Road.

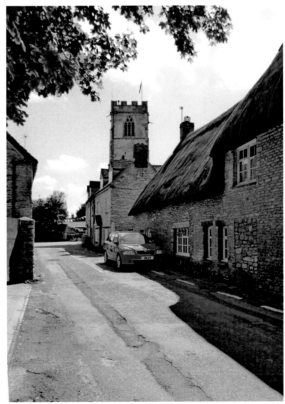

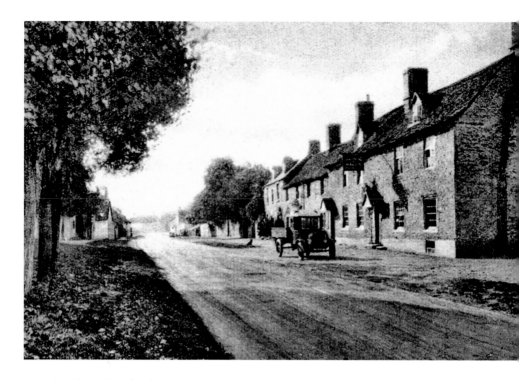

Eynsham: Newland Street

Newland Street, on the east side of Eynsham, was laid-out by the Abbot of Eynsham Abbey in 1215 in an attempt to expand the town and thereby stimulate urban development. However, this medieval 'town-planning' scheme achieved only partial success and, even today, there are many gaps between the Cotswold stone buildings – suggesting that many of the burgage plots had remained empty. The Newlands Inn can be seen to the right in both pictures.

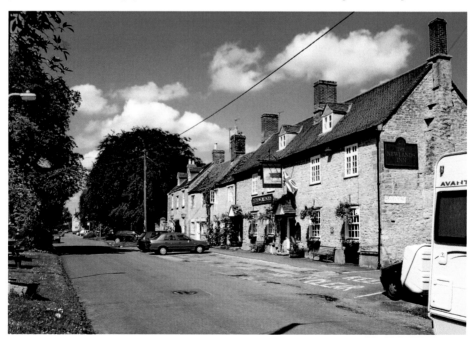

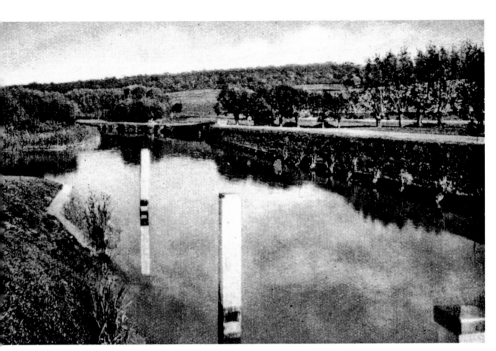

ynsham: The River Thames

he Thames has been navigable or centuries, and in medieval imes the river was regarded as a major artery of communication or stone, timber and other eavy consignments. Although ynsham is situated about half-a-nile to the north of the Thames, his small town was once a busy rading port, and boats were ble to reach Eynsham Wharf by neans of a navigable side stream, nown locally as 'The Naith', that xtended north-westwards from he river and terminated on the ast side of the Witney road. This hort waterway, a little over half--mile in length, was owned by he Oxford Canal Company.

Eynsham Lock, 7 miles 9 hains from Oxford, was built s recently as 1928 to replace a veir or 'flash-lock'. The lower hotograph shows the lock hamber, looking west towards winford Bridge in 2012, while he sepia postcard view is ooking in the opposite direction owards Oxford, c. 1930.

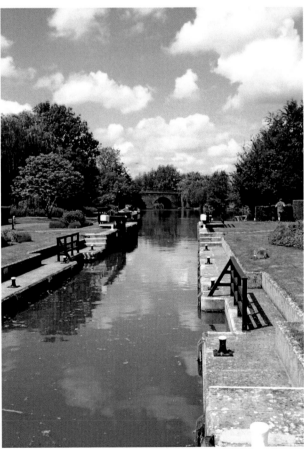

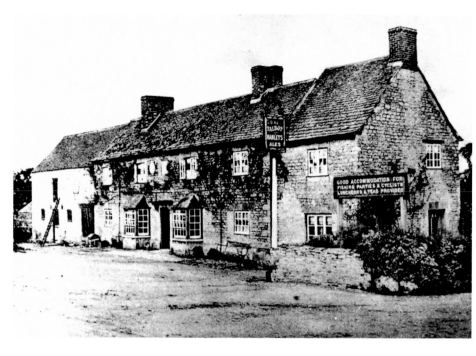

Eynsham: The Talbot & Eynsham Wharf

Eynsham 'Hythe' or Wharf is mentioned in a lease of 1302, and in pre-railway days it handled coal imports for Witney and the surrounding district. The eighteenth century saw many improvements in terms of transport, the Thames being linked to the Midlands via the Oxford Canal and to the River Severn via the Thames & Severn Canal – both of these waterways being completed by 1789. The Talbot Inn was owned by the Oxford Canal Company, and formed part of the wharf buildings.

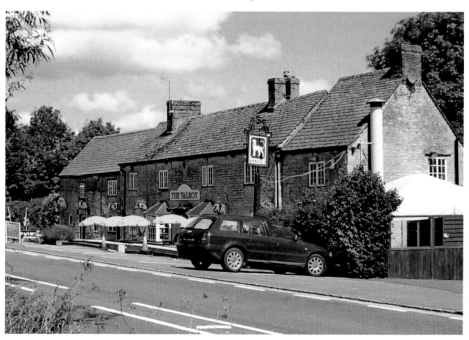

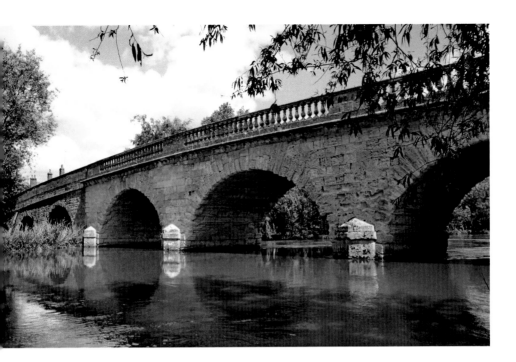

Eynsham: Swinford Toll Bridge

The road from Witney to Eynsham was improved and widened during the eighteenth century – the toll bridge at Swinford being opened in 1769 to replace an earlier ferry. This new transport link meant that, by the end of the eighteenth century, coal and other heavy goods could be conveyed to Eynsham Wharf and then taken by road to Witney, Burford or other destinations. The upper view shows the bridge from the south-west, and the sepia view is of *c.* 1920.

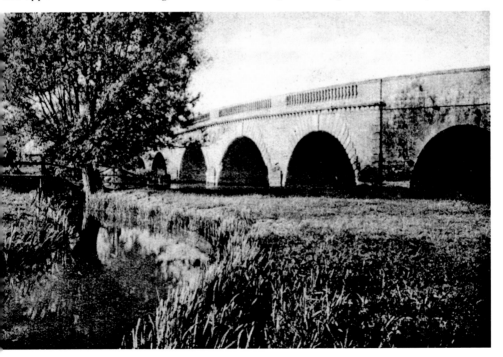

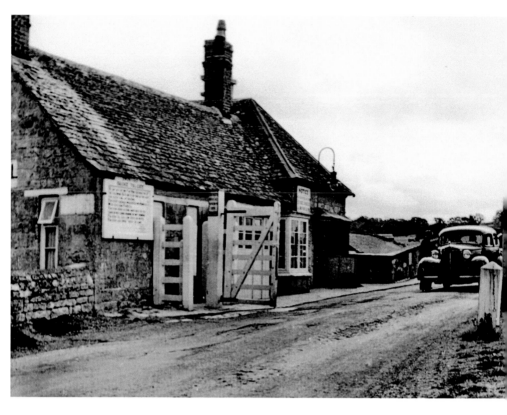

Eynsham: Swinford Toll Bridge

The bridge, some 7 miles 28 chains upstream from Oxford, is an elegant structure with a balustrade, the toll-house, at the north-western end of the bridge, being a split-level building with its upper floor facing the roadway. The upper view, which is looking south-east towards Oxford, *c.* 1920, shows the white-painted level crossing style toll gate, which has now been replaced by a tiny booth for the toll-collector, as shown in the colour photograph.

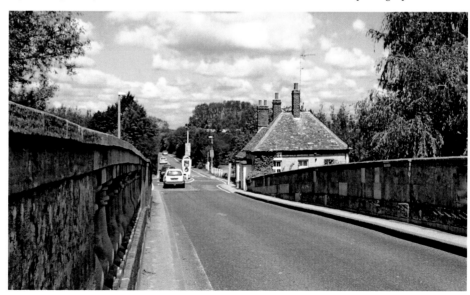

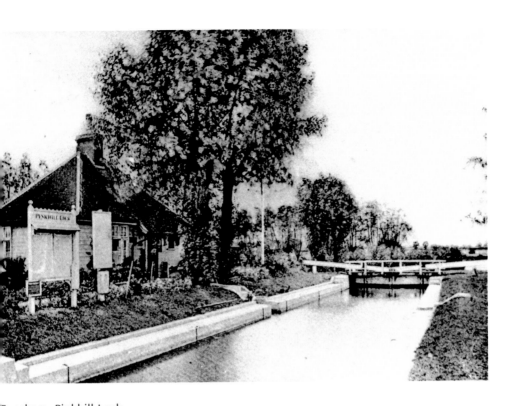

Eynsham: Pinkhill Lock

Pinkhill Lock, about 1½ miles to the south of Eynsham and 8 miles 58 chains from Oxford, was built in 1791 to replace a 'flash-lock'. The upper view is taken from a postcard of c. 1920, while the colour photograph, which is looking north towards Swinford Bridge (about 1¼ miles to the east of Pinkhill Lock), provides a further glimpse of the river at Eynsham. Despite railway competition, the Thames remained a commercial waterway until the twentieth century, the last boatload of coal being taken to Eynsham around 1924.

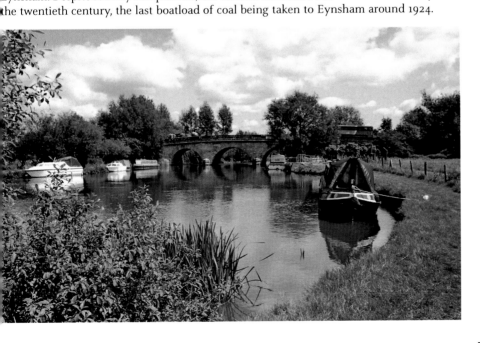

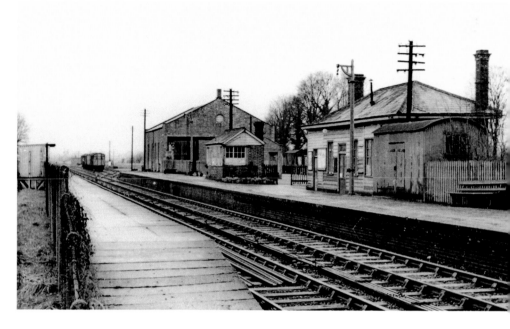

Eynsham: The Railway Station

Eynsham station was opened by the Witney Railway on Wednesday 13 November 1861, and it remained in use for passenger traffic until 16 June 1962. Goods facilities were withdrawn in 1965, and the Witney Railway was closed in its entirety in November 1970. In 1913, Eynsham station issued 12,220 tickets, falling to 2,243 in 1932, and 1,337 by 1938. Goods traffic amounted to about 1,800 tons per annum during the later 1930s. The site is now an industrial estate, as shown below.

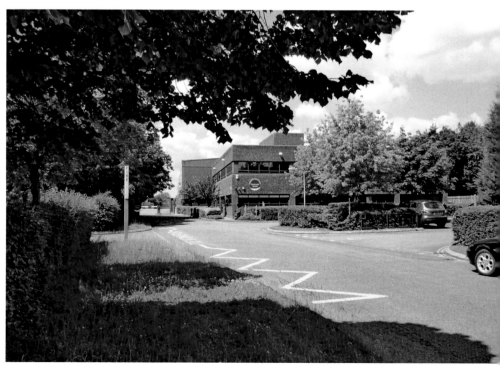

Hailey: Clapton Crabbe Rolfe & St John the Evangelist Church

Hailey originated as a woodland hamlet within the manor of Witney, but it acquired its own church in 1761, when a chapel-of-ease was erected, this small building being shown in the upper picture. The foundation stone of a new and much larger church was laid by the Duchess of Marlborough on 15 April 1868, and the new place of worship was consecrated on 6 April 1869.

The church was designed by Clapton Crabbe Rolfe (1845–1907), the incumbent's son, and a nephew of the prolific Witney architect George Wilkinson. The young architect had produced a Gothic building that was described by the Diocesan architect as 'needlessly eccentric', while a more recent authority refers to 'fantastic Gothic in colourful materials with bulbous forms and freakish detail', the bell turret being a 'particularly bizarre' feature.

C. C. Rolfe subsequently built or rebuilt several other local buildings, including All Saints Church at Nuneham Courtney, and St James College at South Leigh, but it came as a great disappointment when he failed to succeed G. E. Street as Diocesan architect – the implication being that his 'High Church' views (implicit in the design of Hailey church) had irreparably harmed his career prospects.

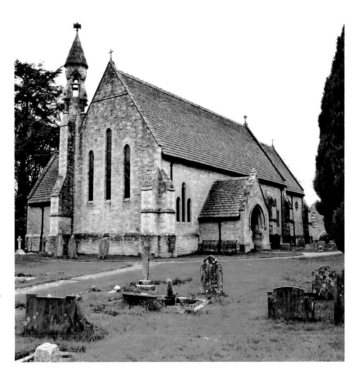

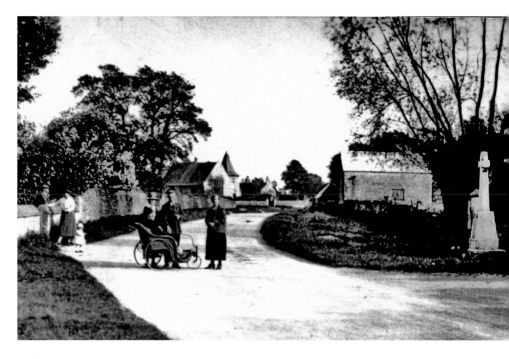

Hailey: Looking Towards Witney

Two views of Hailey, looking south along the B4022 road towards Witney. The upper picture, dating from about 1925, provides a glimpse of the Wesleyan Chapel, with its stubby broach spire, while the lower photograph, which was taken from a position slightly further to the north, shows a group of typical Cotswold-style buildings on the corner of Church Lane; the Methodist Chapel is now a private dwelling.

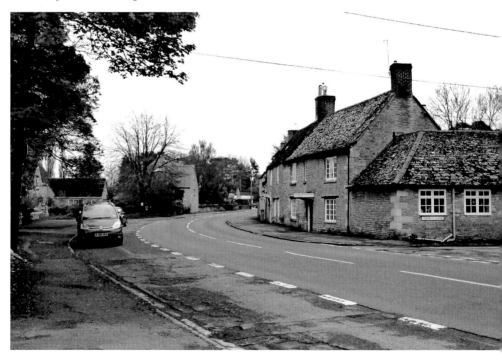

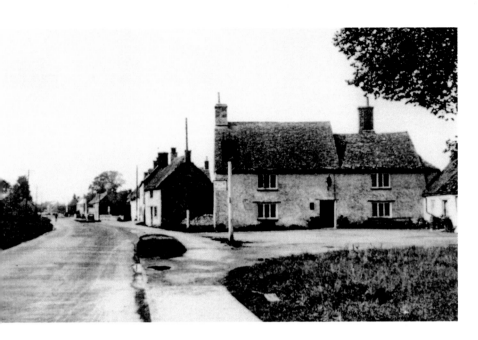

Handborough: The George & Dragon

Handborough (also spelt Hanborough) is really two distinct villages, Church Handborough, with its medieval parish church, being the oldest of the two settlements, while the appropriately-named 'Long' Handborough extends for approximately two miles along the present A4095 road. In 1841 the parish of Handborough contained 1,009 inhabitants, while at the time of the 1901 census the population was 879. The upper view shows Long Handborough *c.* 1912, whereas the colour photograph was taken in 2012; the George & Dragon features prominently in both views.

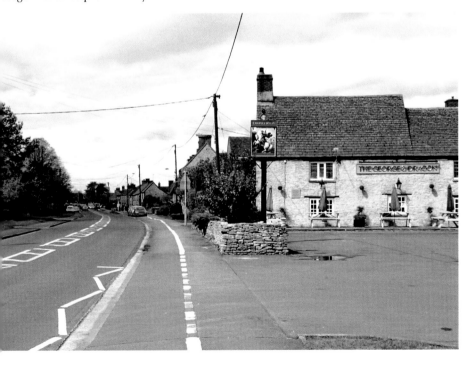

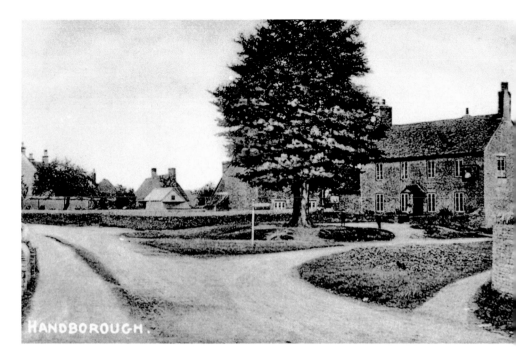

Handborough: The Swan

The former Swan Inn, in Long Handborough, forms part of a cluster of Cotswold stone dwellings in Millwood End, on the north side of the A4095, which were probably the nucleus of the original hamlet. The proprietor of the Swan, in 1852, was Edward James. The postcard view dates from *c.* 1912, while the colour picture, taken in 2012, reveals that little has changed in this picturesque corner of the village.

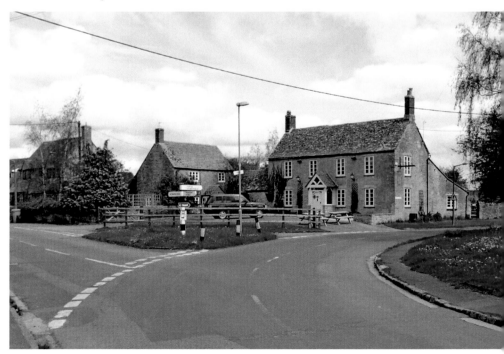

Handborough: The OW&WR

The station, which is sited on the east side of Long Handborough, was opened by the Oxford Worcester & Wolverhampton Railway in 1853. On 30 January 1965 it achieved national fame when the body of wartime Prime Minister Sir Winston Churchill was brought by special train from Waterloo for private burial in nearby Bladon churchyard. The special was hauled by 'Battle of Britain' class locomotive No. 34051 *Winston Churchill*, and the train included the Pullman cars *Carina*, *Perseus*, *Lydia* and *Isle of Thanet*. A bus museum has been established in the former goods yard, and this now contains an interesting collection of public service motor vehicles. The station had remained in operation, although it is now an unstaffed halt, as shown in the recent photograph.

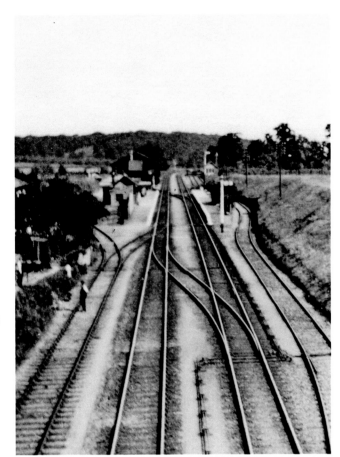

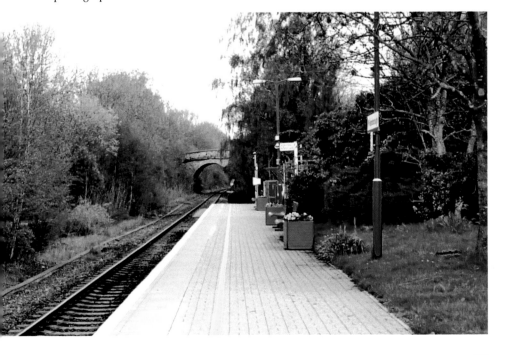

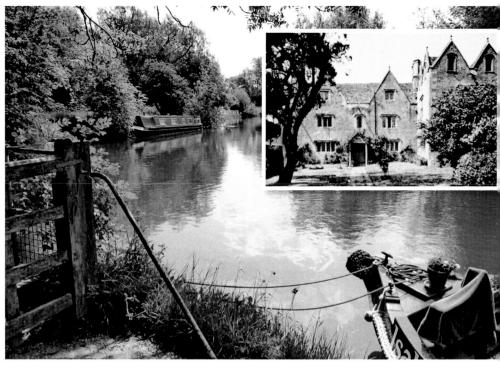

Kelmscott: The Home of William Morris

Kelmscott, about five miles to the west of Bampton, was the 'holiday home' of William Morris (1834–96), the Victorian writer, artist and social reformer, who rented the manor house from 1871 until his death in 1896. The house itself is of sixteenth-century origin, although the prominent north-western wing was added about 100 years later.

Kelmscott Manor was purchased by Jane Morris (*nèe* Burden), William's widow, in 1913, and she continued to live there with her daughers Jenny and May, until her own death in 1914. Thereafter, the property passed to May Morris, who died unmarried in 1938; the entire family are buried in the nearby Church of St George. The manor house is situated within a few yards of the River Thames, as depicted in the upper illustration, while the sepia inset shows the house *c.* 1930s.

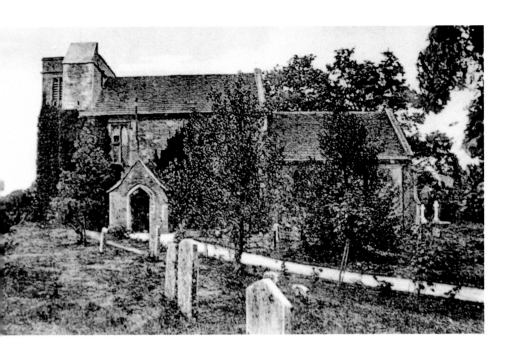

Kencot: St George's Church

Kencot is a small, Cotswold stone village on a low-lying site amidst flat water meadows. The tiny Norman church of St George has an interesting tympanum above its doorway with a shallow relief depicting a centaur – half-man and half-horse – shooting an arrow into a monster. It has been suggested that this mythical figure is Chiron, the wisest of the centaurs who, according to classical mythology, was given a place among the stars as Sagittarius.

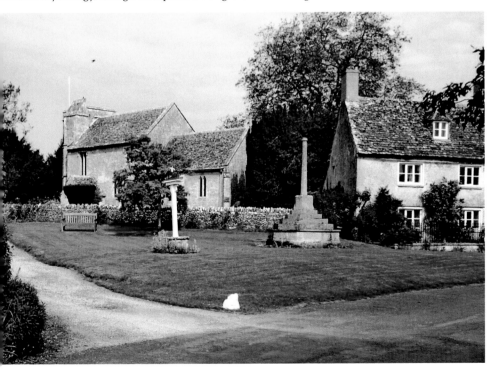

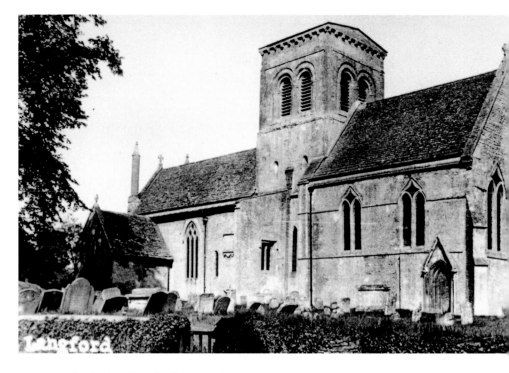

Langford: The Church of St Matthew

Langford, a pleasant, Cotswold stone village, sited about four miles to the west of Bampton, has an interesting church. The eleventh-century tower, with its corner pilasters and boldly-arched bell-openings, is of Anglo-Saxon origin. The nave is very narrow, but side aisles were added *c.* 1200, and the chancel was remodelled a few years later. The enlarged nave and new chancel are somewhat wider than the tower, which has been standing for over 900 years, and may well be 1,000 years old.

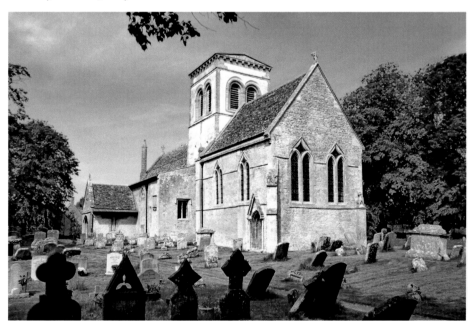

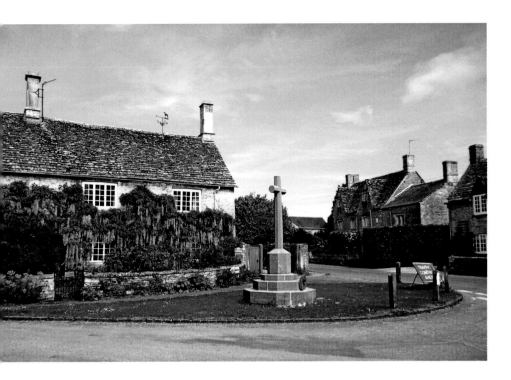

Langford: The War Memorial

Langford War Memorial was unveiled in 1920, two years after the First World War, which had claimed the lives of nine young men from the village. A further three names were added to commemorate those who died in the Second World War. The upper picture shows the memorial in 2012, while the lower picture shows the unveiling ceremony – this photograph was apparently taken from a first-floor window of the Cotswold stone house that can be seen in the colour view.

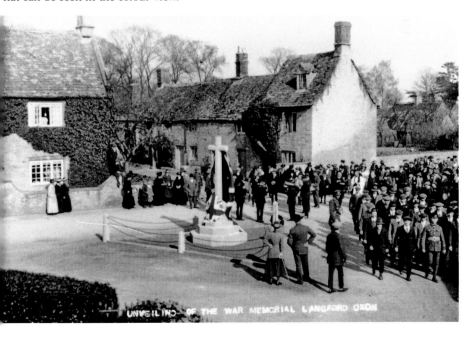

UNVEILING OF THE WAR MEMORIAL LANGFORD OXON

Leafield

Leafield originated as a woodland hamlet in the parish of Shipton-under-Wychwood. Its population, in 1841, was 737, rising to 860 by 1901. The original settlement was created by 'assarting', or cutting down trees on a ridge of high ground in the depths of Wychwood forest and, even today, there is much woodland in the vicinity – a substantial fragment of the former royal forest being sited to the north-east of the village.

The area has an elevation of around 600 feet above mean sea level, and winters hereabouts can be surprisingly bleak, as suggested by the lower photograph. In 1913, a wireless station was established at Langley Farm, to the north-west of the village, and a cluster of 'Marconigraph' masts were erected. Thereafter, the so-called 'Leafield Poles' remained a prominent local landmark until the closure of the radio station in the 1980s.

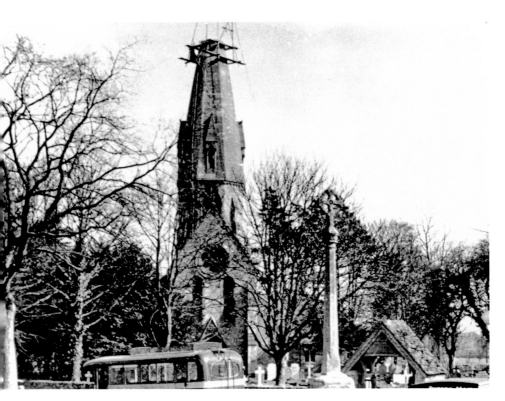

Leafield: St Michael's Church

Leafield's Victorian church, incorporating a nave, aisles, tower and chancel, was designed by Sir George Gilbert Scott (1811–78), and consecrated in 1860, although its prominent spire was not completed until 1874. The bells were added in 1875, and one of these was a gift from Queen Victoria. The upper view shows repair work being undertaken on the top of the spire, probably *c.* 1930, while the colour view was taken in 2012. On a footnote, it may be worth adding that Sir George Gilbert Scott was one of Victorian Britain's leading architects, and he designed many famous buildings, including St Pancras Station, the Foreign & Colonial Office and the Albert Memorial.

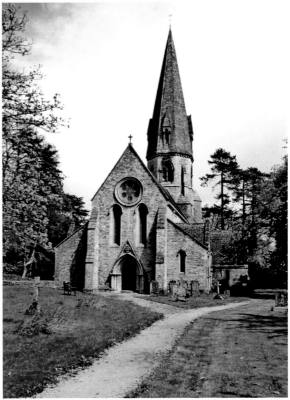

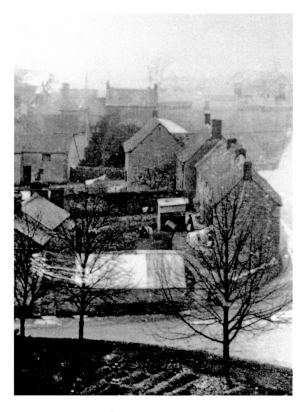

Leafield: The Captain's Daughter

Pratt's Cottage on the Green at Leafield was, for many years, the home of Helen Russell Cooke, the daughter of Edward J. Smith, the captain of RMS *Titanic*. On 18 August 1930 her husband, Sidney Russell Cooke, a stockbroker who was said to have suffered from shell shock during the First World War, died in a shooting incident in his chambers at Kings Bench Walk, London; he was apparently cleaning a fully-loaded shotgun while holding it towards his stomach, when it went off. A few months later, on 28 April 1931, Mrs Russell Cooke's mother, Eleanor Smith, died after being knocked down by a taxi cab outside her London home.

Mrs Russell Cooke's life was punctuated by further sadness – her daughter Priscilla died of polio in 1947, while her son, Flying Officer Simon Russell Cooke, was killed while serving with the RAF in the Second World War. By a tragic coincidence, Simon was lost at sea, his Beaufighter having been shot down while taking part in operations against enemy shipping off the Norwegian coast on 23 March 1944; his body, and that of his navigator, were never recovered.

Despite these tragedies, Mrs Russell Cooke lived a very full life, which included service as a special constable during the Second World War. She died at Leafield on 18 August 1973, but local people still talk of 'the *Titanic* Captain's Daughter', whose father, mother, husband, son and daughter all died in tragic circumstances (thus helping to perpetuate the *Titanic* myth). Her son Simon Russell Cooke is commemorated on the Roll of Honour in Leafield parish church. The lower photograph shows cottages on the south side of the Green at Leafield, Pratt's Cottage being hidden behind the hedgerow to the left of the picture.

Inset: RMS *Olympic*, the *Titanic*'s twin sister; E. J. Smith served as captain aboard both vessels.

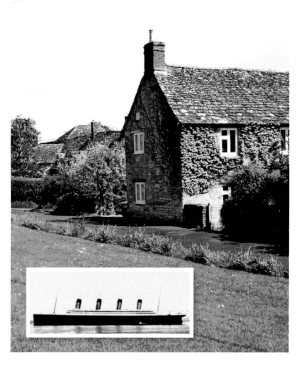

Minster Lovell: The Demise of Lord Francis Lovell

Minster Lovell passed into the hands of the Lovell family during the reign of Henry I, and the Lovells remained lords of the manor until 1487, when Francis, the 9th Baron Lovell, the favourite of King Richard III, was attainted of high treason after the Battle of Stoke. The ruins of Lord Lovell's extensive manor house are situated in an idyllic position beside the River Windrush, while the Old Swan Hotel is also of great antiquity.

Legend asserts that Lord Lovell returned to Minster Lovell after the Battle of Stoke, and was able to hide in a secret vault within the great manor house. The room was fully furnished, and the last Lord Lovell is supposed to have remained in hiding for many months, perhaps even years, food being brought by a trusted servant. The end of the story has an inevitable conclusion, in that the servant died and Lord Lovell starved to death, his hiding place having become his tomb.

About two hundred years later, when alterations were being made within the manor house, the hidden chamber was discovered. In it was the body of a man, sitting at a table, with books, paper and a pen in front of him. No sooner had the air penetrated the apartment than the figure collapsed, and when the spectators ran to inspect the mystery all that remained was the rich dress of a noble, and the dust of Lord Lovell's body'.

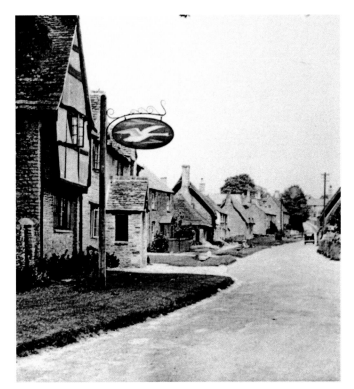

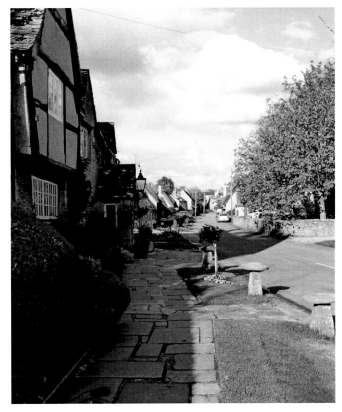

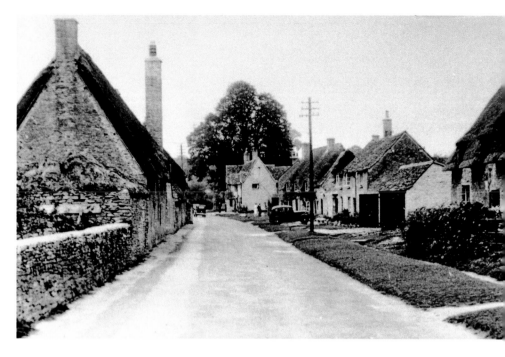

Minster Lovell: Looking West along the Village Street

A view along the main street at Minster Lovell, looking west towards the Old Swan. The decrepit old cottages visible in this *c.* 1930s view were eventually adapted for new use as summer retreats for the rich and famous, while the Old Swan Inn – once the village pub – was transformed into a prestigious middle-class hotel and restaurant. Many of the cottages on the south side of the street had attractive gardens that bordered the adjacent Wash Meadow.

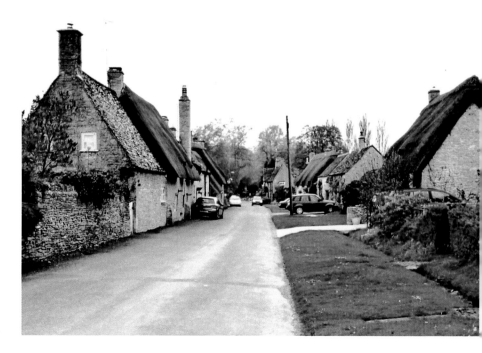

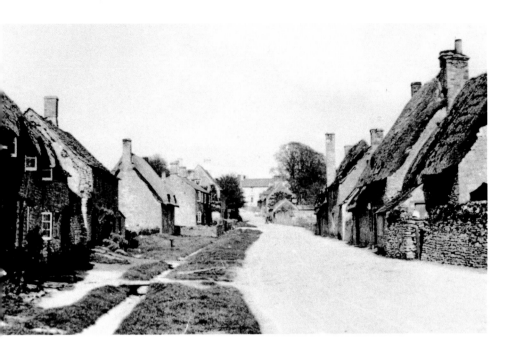

Minster Lovell: Looking East

Two further photographs of the village street, this time looking east. The thatched stone cottage that can be seen on the left in both photographs is known as 'The Rosary'. It is probably of Tudor origin, although its foundations may be late medieval. The house next door with the slated roof is Lovell Cottage, while the cottage on the opposite side of the street was the home of Harry Baker, who worked as a herdsman during the 1950s.

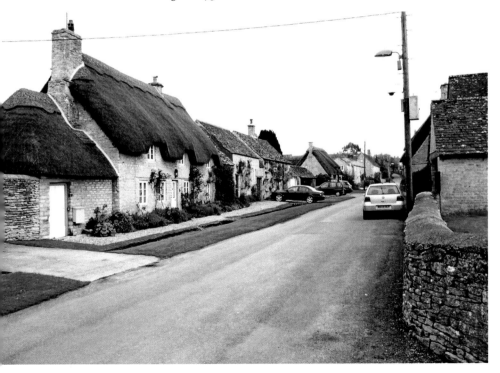

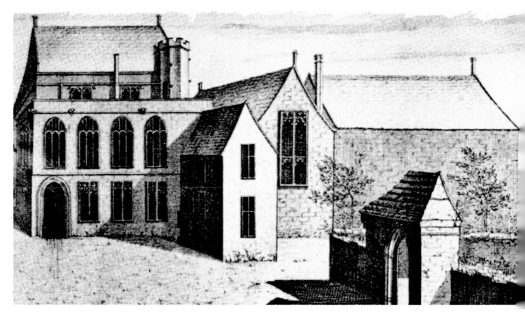

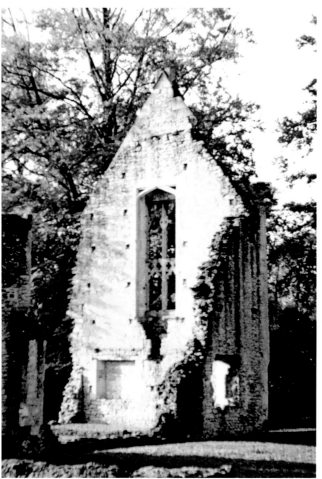

Minster Lovell Ruins: The Demise of the Lovell Mansion
After serving as an occasional royal residence for several years, the manor house was rented to minor gentlemen such as Alexander Unton, who leased the property in 1536 for a period of twenty-one years. In 1602 the estate was purchased by Sir Edward Coke (1552–1634), the Lord Chief Justice of England, but there is no evidence that the Cokes ever lived at Minster Lovell, and the property continued to be rented-out to suitable tenants.

In the 1740s the then owner, Thomas Coke, moved into his new mansion at Holkham in Norfolk, and the manor house was dismantled; much of the stone being carted away for re-use around the village. The upper illustration, taken from a Buck print, depicts the Lovell mansion prior to its demolition. In 1935 the ruins were placed in State Guardianship as an Ancient Monument, and in the late 1930s the overgrown site was cleared and restored.

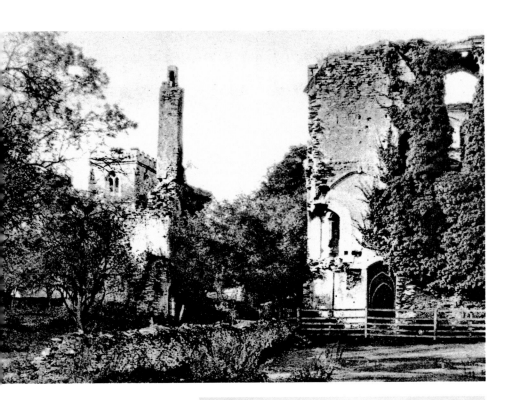

Minster Lovell Ruins: The South Tower

In its fifteenth-century heyday, this large manor house consisted of two quadrangles, with the Great Hall and other domestic accommodation at its centre. The South Tower, which stands within a few feet of the River Windrush, contained four levels, the ground floor being merely a toilet or garderobe, while the uppermost storey contained a large chamber with an oriel window, traces of which can still be seen.

The second storey features a small opening with a widely-splayed embrasure on its inner face, suggesting that it served as a gun-loop. Access to the first floor was by means of an external stair, while entry to the upper floors was via an octagonal stair turret built into the angle between the tower and the West Wing. The top of the tower was crenellated, the stair turret being continued up to roof level in order to provide access to the battlements.

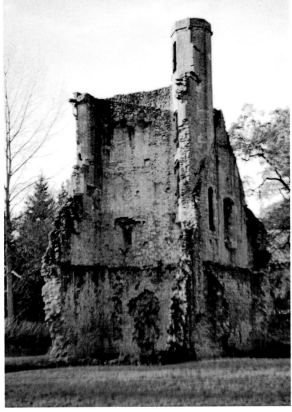

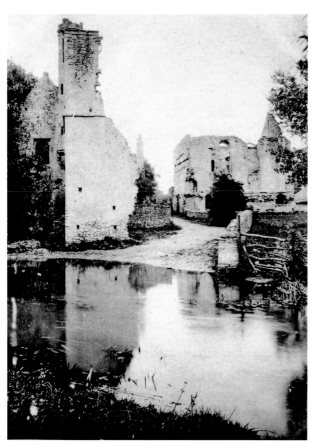

Minster Lovell Ruins: The Great Hall

The upper view shows the South Tower *c.* 1900, with a farm track running beside it. The lower picture depicts the Great Hall, which was the largest room in the building, and the centre of social activities. The hall at Minster Lovell was an anachronistic feature in the late fifteenth century, in that it had no heating arrangements other than an open hearth in the centre of the floor.

The hall measures 26 feet by 50 feet at ground level, with a height of about 40 feet from floor to wall plate level. Above this, the rafters would have been fully exposed, the idea being that smoke from the central hearth would escape through openings high in the gables. The Great Hall was flanked by two suites of domestic rooms, the Lord's Great Chamber being to the west, while a lesser chamber at the east end probably functioned as the Steward's Room.

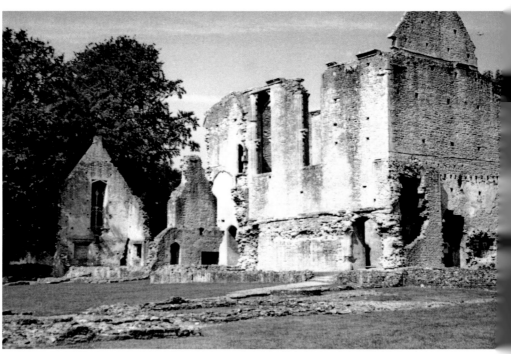

Minster Lovell: Feargus O'Connor & the Charterville Allotments

On 24 June 1847, an eccentric Irish gentleman named Feargus O'Connor (1796–1855) purchased 3,000 acres of meadowland with the aim of creating a model agricultural community. Feargus was a leader of the Chartist Movement, which hoped to improve the lot of the working classes through political reform. Drawing on his experiences in Ireland, his answer to the problems of industrialisation was a retreat to the land, and five model estates were therefore set up, one of these being at Minster Lovell.

Each estate consisted of single-storey, Irish-style cottages as shown in the illustrations. The Minster estate, which was dubbed 'Charterville', contained seventy-eight cottages, including fifty-seven on either side of the Brize Norton Road, and smaller numbers on the Cheltenham road and at Bushey Ground. The cottages were hipped-roof structures containing domestic rooms and service rooms, including accommodation for cows, hens and pigs. The cottages were said to have been designed by Feargus himself.

The first allottees arrived in the summer of 1848, their names having been chosen by a lottery. Most of the new tenants were industrial workers from northern England, though one or two came from Worcestershire or other nearby counties. Unfortunately, the 'Charterville' experiment was a total failure. The allottees were not skilled farmers, the land was poor, and the 1840s were a period of wet weather and failed harvests. Slowly but inexorably the original tenants drifted away, and by 1851 the only three former Chartists remained. In the fullness of time the vacant smallholdings were taken over by local people, many of whom specialised in the cultivation of potatoes or other cash crops. In later years, many Charterville residents worked in Witney and cultivated their smallholdings on a part-time basis, while numerous new houses were subsequently erected among the distinctive Chartist cottages.

Inset: Another Charterville cottage.

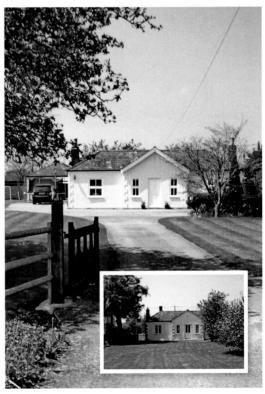

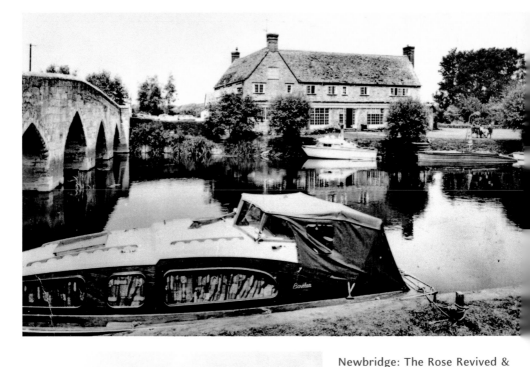

Newbridge: The Rose Revived & the Maybush

Newbridge, some 14 miles 61 chains upstream from Oxford, is situated at the confluence of the Thames and Windrush; the bridge, which has six pointed arches, dates from the fourteenth century. In 1766, a meeting held in the Crown Hotel at Witney resulted in an application to Parliament for powers to construct a turnpike road from Witney to Newbridge, and when the road was completed it provided a useful transport link for coal and other heavy goods between Witney and the Thames.

There are two pubs at Newbridge, the Rose Revived being on the north bank while the Maybush Inn is on the south side of the river. The upper view shows the Rose Revived from the south bank, *c.* 1930, while the colour view was taken from the north bank in 2012, looking west towards the ancient bridge; the Maybush can be seen to the left of the picture.

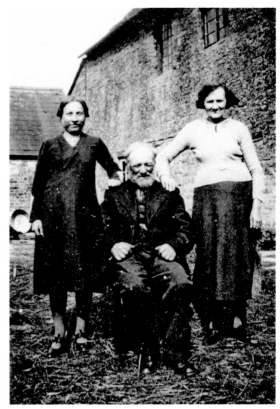

New Yatt: Home Farm

The tiny hamlet of New Yatt, about 2½ miles to the north-east of Witney, consists of little more than a pub, some scattered cottages and a handful of farms, one of these being Home Farm. This *c.* 1940 photograph shows retired farm worker Jason Trinder and his two daughters Martha Trinder and Sarah Green, who had recently moved from South Leigh to New Yatt. The photograph was taken in the yard at the rear of the old farmhouse at Home Farm, whereas the recent colour photograph shows the front, with New Yatt Road in the foreground.

Inset: Jason Trinder, still working at the age of seventy-two, with a horse plough near Eynsham, *c.* 1938.

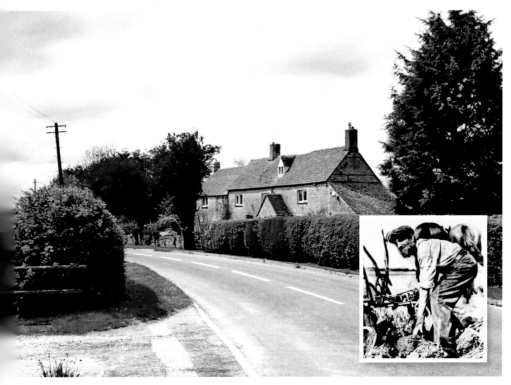

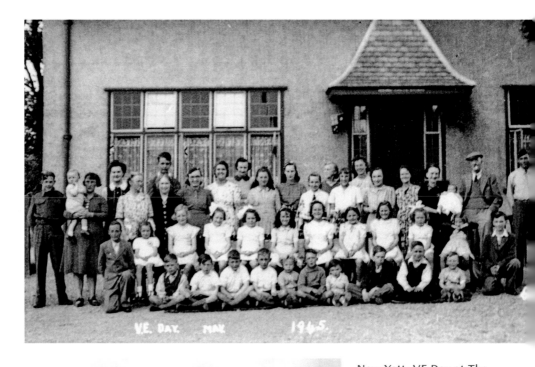

VE. DAY. MAY. 1945.

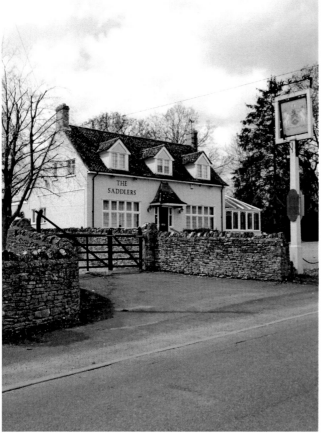

New Yatt: VE-Day at The Sadler's Arms

The upper view shows VE-Day celebrations under way in May 1945 outside The Sadler's Arms pub in New Yatt Lane, many of the village children having been assembled for the photographer. The colour photograph shows The Sadler's Arms bar and restaurant in 2012. The Saddler's Arms is said to have been opened as a 'beer house' by a family of saddlers during the Victorian period, although the building was substantially rebuilt during the early twentieth century.

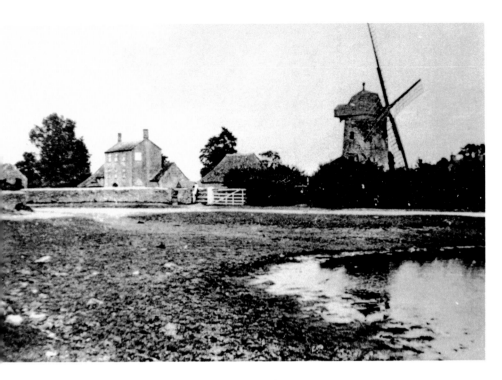

North Leigh: Junction of Park Road & Common Road

North Leigh is a typical Cotswold stone village on the ridge of high land between the rivers Windrush and Evenlode. It is noted for its windmill and its Saxon church, while in the 1780s a Romano-British villa was discovered at East End, about 1½ miles to the east of the village. The villa was excavated in 1815, and in 1952 the site passed into the care of the Ministry of Public Buildings & Works (now English Heritage) as an Ancient Monument.

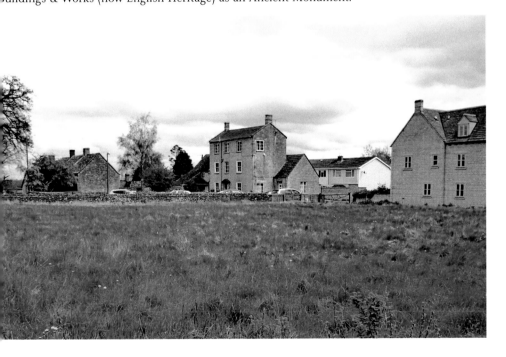

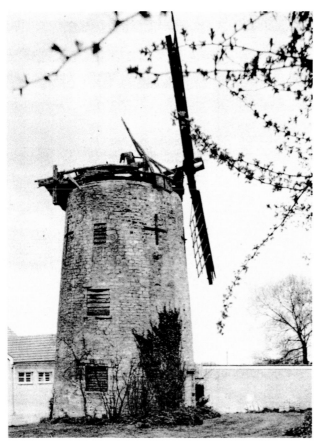

North Leigh: The Old Windmill

North Leigh windmill was a tower mill with a rotating wooden cap that allowed the sails to be turned into the wind. The windmill was probably built around 1830, and it remained in use for over a century. However, this prominent local landmark had fallen into disrepair by the 1950s and, thereafter, the owners of the mill allowed it to fall into near-ruin. The land around the windmill was subsequently sold-off for housing development, although the stone tower has survived, minus its sails and covered in ivy, but with a new weather-proof cap, as shown in the lower illustration.

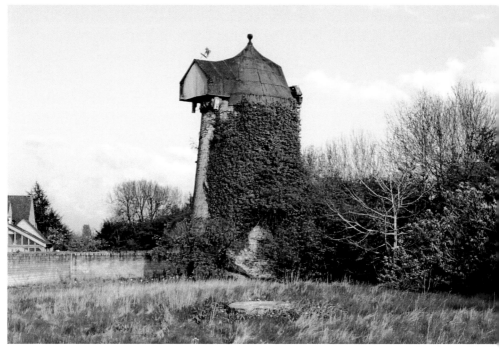

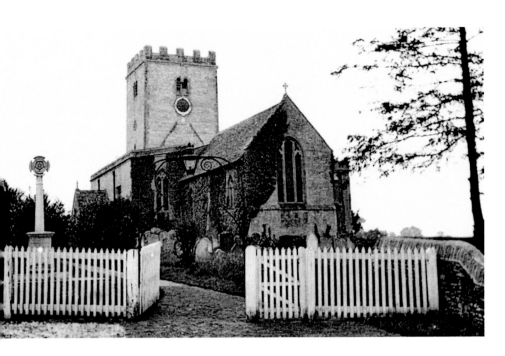

North Leigh: St Mary's Church

Unlike the windmill, North Leigh church remains intact, as shown in these photographs, the upper view dating from *c.* 1930, while the lower was taken in 2012. The pre-Norman Conquest tower, built around 1000 AD, has characteristic round-headed arches, which are typical of the Romanesque period. In medieval times the chancel was enlarged and rebuilt to become the present nave, while the original nave was demolished, leaving traces of its roof line on the west wall of the 1,000-year-old tower.

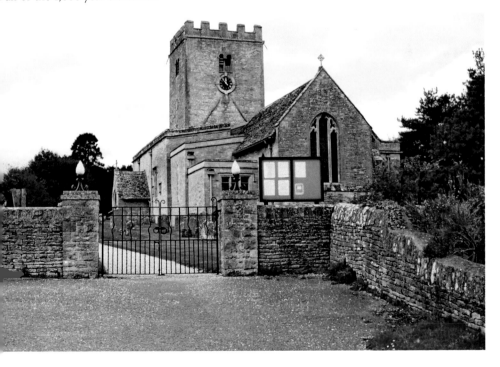

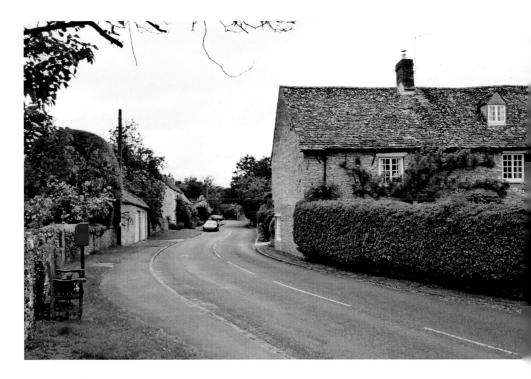

Ramsden

Situated between Witney and Charlbury, Ramsden was once surrounded by Wychwood Forest, and the area is still well-wooded. During the Second World War an American military hospital was established at Ramsden Heath for use after the D-Day operation, though fortunately the invasion resulted in less casualties than had been anticipated. Today, the ruined hospital is one of many reminders of the 1939–45 war in West Oxfordshire. The photographs show two views of Ramsden, one in 2012, the other in *c.* 1912.

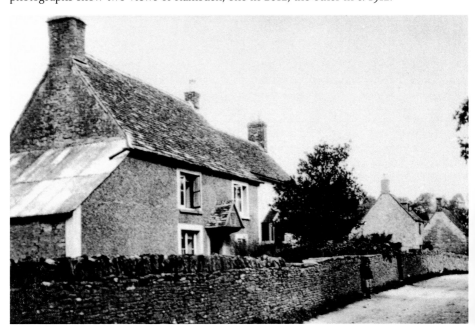

Shilton: The Rose & Crown

Situated amidst steep, well-wooded hills, about 4½ miles to the north-west of Bampton, Shilton is an archetypal Cotswold village, with a twelfth-century church and a seventeenth-century manor house. The straggling main street has changed little over the years, the upper view having being taken from an old postcard of *c.* 1912, while the lower view was photographed a century later. The Rose & Crown, which can be seen in both pictures, is a traditional village pub; in 1852 the landlord was William Spencer, who is described in *Gardner's Oxford Directory* as a 'shop-keeper and victualler'.

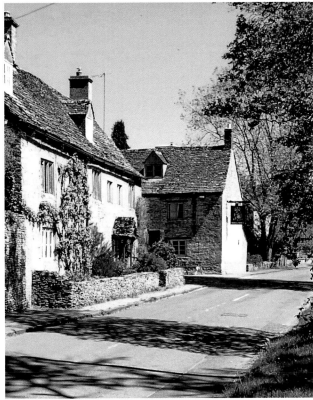

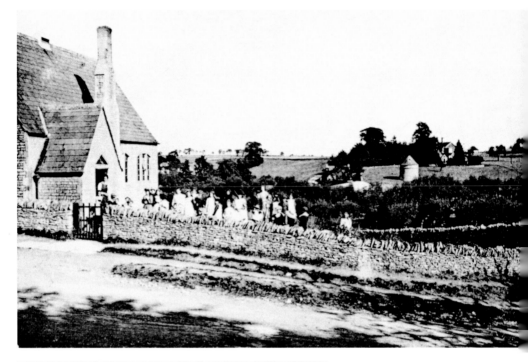

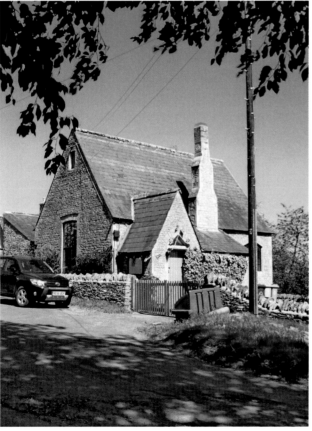

Shilton: The Old Village School

Shilton's former National School, now the village hall, occupies an elevated site in Church Lane, high above the valley of the Shill Brook. The school was built around 1864, as an Anglican school for about forty to fifty pupils, and it remained in use until 1970, after which the redundant building was purchased for use as a village hall. Like many Church of England schools, Shilton School was built in the Gothic style, and sited in convenient proximity to the parish church, so that the vicar could exercise a degree of control over the syllabus and keep a wary eye on the day-to-day conduct of the school.

Shipton & Thrupp: The Oxford Canal

Shipton-on-Cherwell, a small village about two miles to the east of Woodstock, has a small church beside the Oxford Canal which, at this point, incorporates part of the River Cherwell. Shipton Bridge, seen in the upper photograph, carries a footpath which leads to the deserted medieval village of Hampton Gay, and it also marks the northern limit of a broad stretch of tree-lined waterway known as 'Thrupp Wide', which is popular with artists and fishermen. The Oxford Canal was opened between Hawkesbury Junction and Banbury by 1778, and completed throughout to Oxford in 1789–90. Although eclipsed by the railway after about 1850, the waterway continued to carry commercial traffic until the 1950s.

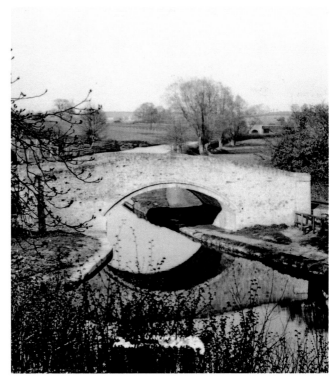

The lower illustration shows the preserved Clayton 'river' class narrow boat *Towy* at Thrupp, immediately to the south of Thrupp Wide; built in 1938, the *Towy* was originally a flush-decked 'tanker', but she has now been fitted-up as a sheeted boat. The *Towy*'s sisters *Tweed* and *Rea* were among the last trading boats seen on the canal; they were crewed by Mr and Mrs Albert Beechey, and carried gas tar from Oxford Gasworks to distillers in the Midlands. Another Claytons 'pair' seen on the Oxford Canal during the 1950s were the *Umea* and *Orwell*, which replaced *Tweed* and *Rea* on the Oxford run. A further view of Thrupp Wide will be found on the following page.

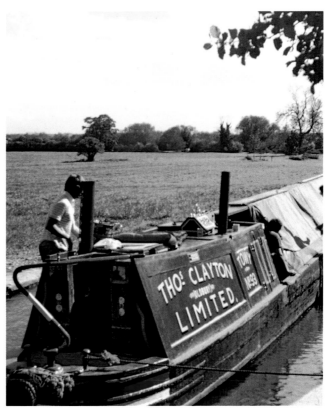

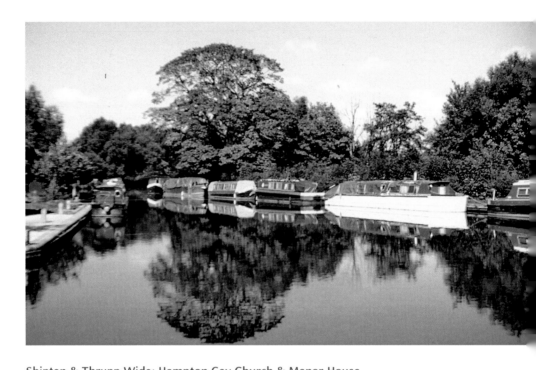

Shipton & Thrupp Wide: Hampton Gay Church & Manor House

On Christmas Eve 1874, Hampton Gay was the scene of a train crash in which thirty-four people lost their lives. The dead and dying were carried to Hampton Gay manor house and an adjoining paper mill, which had been pressed into service as a morgue. The house was burned down in 1887, and local people said that the place was cursed – yet it is a pleasant enough walk across the fields from Thrupp Wide to the church and manor house.

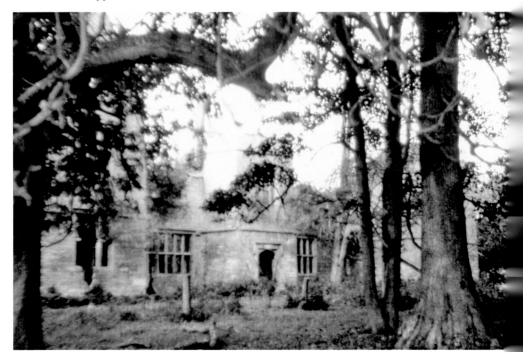

South Leigh: Cottages at Church End

The secluded village of South Leigh was once a detached part of Stanton Harcourt, its original name being 'Stanton Leigh'. However, in the fullness of time, it became an entirely separate village, with its own parish church.

In the 1920s, these six semi-detached Cotswold stone cottages at Church End housed several families. Henry and Sarah Green lived in the centre cottage with their five children (Aubrey, Richard, Reginald, Vera and Eileen), while 'Grannie Claridge' and her daughter Bessie resided in one of the gabled Victorian cottages that can be seen on the extreme right of the upper picture. Other members of the Claridge family were accommodated in the tiny cottage adjoining Sarah Green's house, and the two houses on the extreme left were occupied by an old lady known as 'Grannie Viner', and Miss Greening, the local school teacher, who taught in the nearby village school.

The six dwellings are still extant, as shown in this 2012 view. Trees and tall hedges prevent a clear view of Sarah Green's former cottage, but Grannie Claridge's house and the adjoining property can nevertheless be seen to the right.

Inset: Grannie Viner in her cottage garden at Church End.

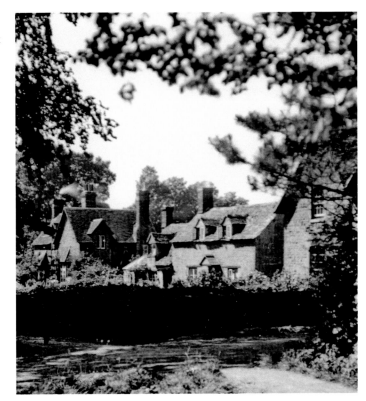

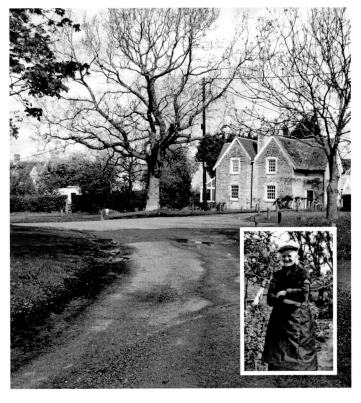

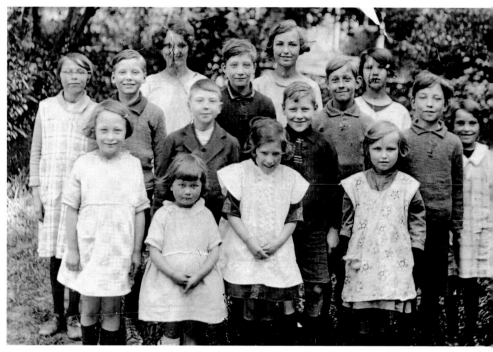

South Leigh: The Village School

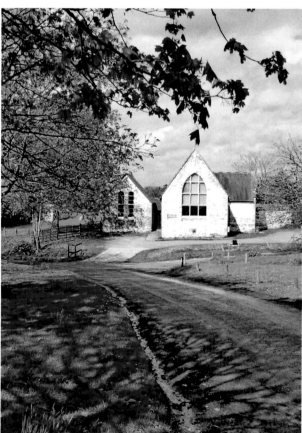

South Leigh National School was opened in 1871, ostensibly for eighty pupils, although in reality its average attendance was very much less. The average attendance in 1931 was just thirty-one pupils and, attendance figures having failed to improve, the school was closed in 1946, although the redundant buildings have now found a new role as a village hall.

The upper picture shows a group of pupils *c.* 1926, including (*left-to-right*) Pearl Harris, Daisy Green, Edna Claridge and Eileen Green in the front row, and Kathleen Keen and Vera Green at the rear. As far as can be ascertained, those in the irregular middle row include Doris Hale, Ernie Hale, Sidney Hale, Ernie Harris, Phyllis Keen, Billy Pearce and Reg Green. Eileen Jenkins (*née* Green), died in 2010, aged eighty-nine, while Edna Smith (*née* Claridge) died in 2012 at the age of ninety-one.

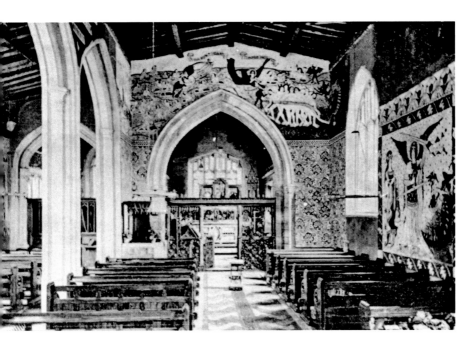

outh Leigh: The Parish Church

'he Church of St James the Great, consisting of a nave, chancel, north aisle, porch and
mbattled west tower, dates mainly from the fifteenth century. It contains some medieval
all paintings, including a 'Day of Judgement' scene above the chancel arch and a depiction
f the Virgin Mary interceding with Saint Michael for the souls of the departed. A plaque
n the early eighteenth-century pulpit recalls that John Wesley preached his first sermon
ere in 1725.

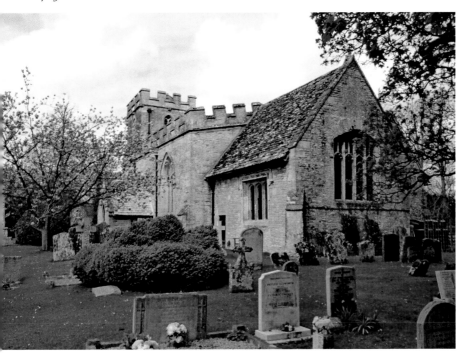

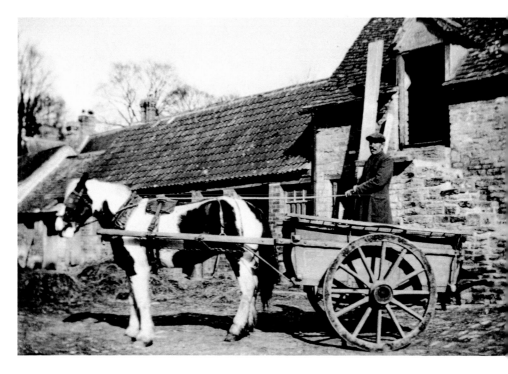

South Leigh: Milk from Church Farm

Oxfordshire dairy farmers supplied large quantities of milk for consumption in London, which was little more than an hour away from Oxford by the fastest trains. Twice a day a succession of milk carts converged on country stations such as South Leigh, which sent upwards of 280–300 gallons of milk to London each day. *Above*: Henry Green and his horse 'Nancy', with the Church Farm milk cart, *c.* 1930. *Below*: A recent view of Church Farmhouse.

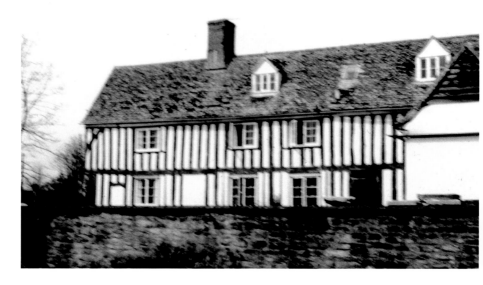

South Leigh: St James's College

St James's College, a large red brick building to the south of the parish church, was built c. 1875 as a 'High Church preparatory school for the sons of English gentlemen', the architect being Clapton Crabbe Rolfe. It could accommodate about forty boys under the age of fourteen, who were prepared under Church influence for entry to Eton or other great public schools. In 1880, one of the pupils described the school as: 'a red brick Gothic building. If you were to see it in front, the first thing which would strike you would be the staircase tower, with its gilt vane, which stands out rather prominently in front of the rest of the building.' On entering the school, one immediately entered a small hall, to the left of which was a large dining hall and school-room, while to the right a staircase led to the dormitories and bed rooms; the dining hall was dominated by a large stone figure of St James the Great.

The building remained in use as a private boarding school for several years, its name being changed to St James's House and, later, Holyrood House. At one stage it housed a community of nuns, while in the Second World War this substantial building was used by the British Council. In October 1956 it became a residential centre for the treatment of nervous illness under ecclesiastical patronage, but the Oxfordshire Area Health Authority eventually took over, and Holyrood House was finally closed in 1994. It has now been converted into private residential accommodation.

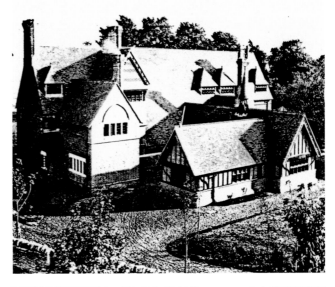

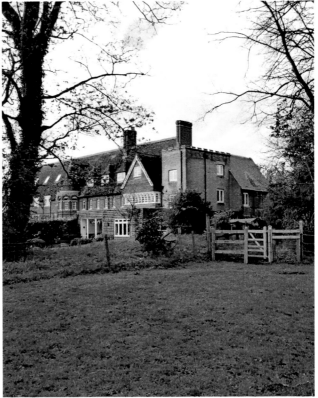

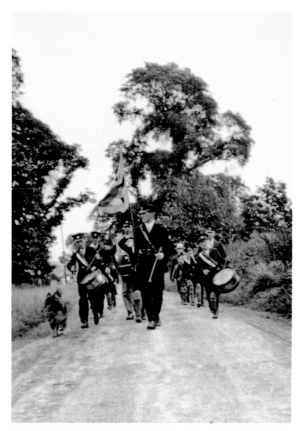

South Leigh: Station Road

The opening of the Witney Railway on 13 November 1861 resulted in the growth of a subsidiary settlement around South Leigh station, which became known as 'Station End' to distinguish it from the original village at Church End – the length of road between the two parts of the village being dubbed Station Road. The upper picture shows a party of Boys' Brigade members from the Midlands marching along Station Road to their annual summer camp-site beside the Witney Road, while the lower picture shows the Mason Arms, which was conveniently-sited roughly midway between Church End and Station End. Originally known as The Sibthorp Arms, it served as the village pub for many years, but has latterly developed as top-class country restaurant and, as such, it is no longer regarded as the village 'local'.

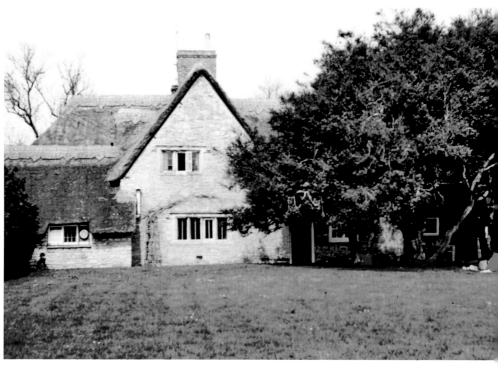

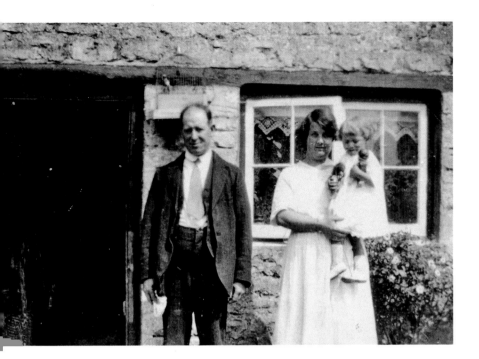

outh Leigh: The Old Post Office

he upper picture shows Herbert (known as 'Herbie') Green, the sub-postmaster and village
xi driver, and his wife Alice, outside the post office and grocer's shop on the north side
f Station Road, *c.* 1930. The old post office has now been combined with the cottage next
oor to form a larger property known as 'The White Cottage', which is shown in the colour
hotograph.

Inset: Alice Green and Vera Green feeding the chickens, with Herbie's motor car visible
the right of the picture.

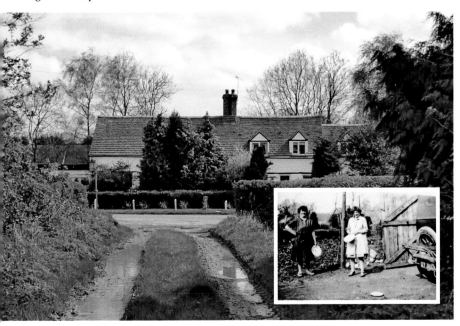

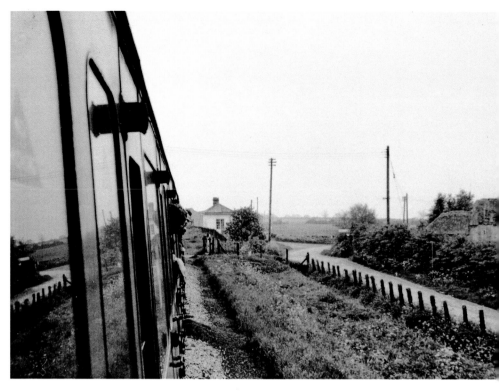

South Leigh: Station End

Left: A view of the diminutive wooden station building at South Leigh, photographed from a train on 24 May 1969; the minor road to Barnard Gate can be seen to the right, while Station Farm can be glimpsed in the right background.

Below: The railway embankment has now been removed, and the station has been replaced by a bungalow, although the former railway is hidden from view by the growth of dense bushes and undergrowth alongside the Barnard Gate road.

Inset: Kathleen Keen, Cybill Keen, Vera Green and Phyllis Keen on the wide grass verge near the station, *c.* 1926.

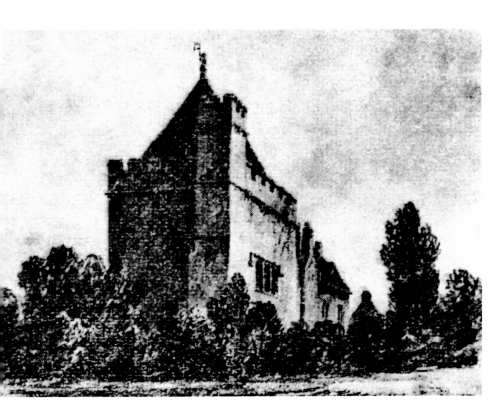

Stanton Harcourt: The Old Manor House

Situated amid flat meadowland to the south-east of Witney, Stanton Harcourt was originally known as 'Stantone'. This name was derived from the presence of three prehistoric upright stones which stood in open fields to the south of the village until 1940, when they were buried beneath the runways of RAF Stanton Harcourt. The Harcourts became lords of the manor in the twelfth century, and the manor house was substantially rebuilt in the fifteenth century. The enlarged house featured a large court or quadrangle, which was unfortified, apart from a low perimeter wall or *enciente*. The Great Kitchen (*above and left*) and Pope's Tower constitute the principal remains – Pope's Tower being named after Alexander Pope, who translated the *Iliad* at Stanton Harcourt in 1717–18.

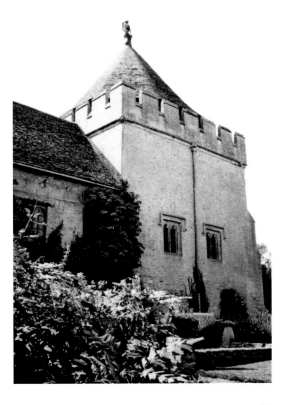

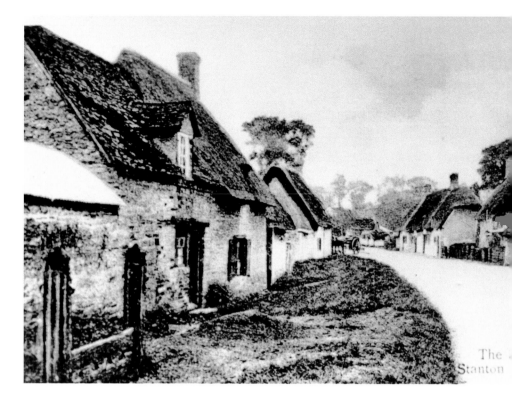

Stanton Harcourt: Old Thatched Cottages

Many of the old stone cottages at Stanton Harcourt had thatched roofs, although the examples depicted in the earlier view have a decidedly run-down appearance; note the stocks which can be seen to the left of the picture. The lower photograph, taken in 2012, shows well cared-for cottages in Main Road, looking north towards the centre of the village.

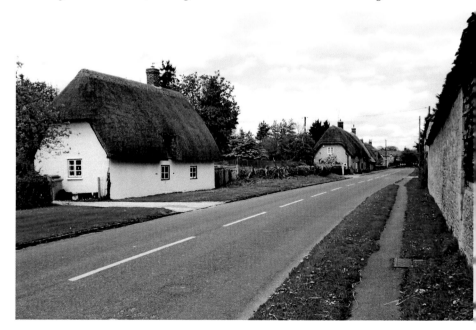

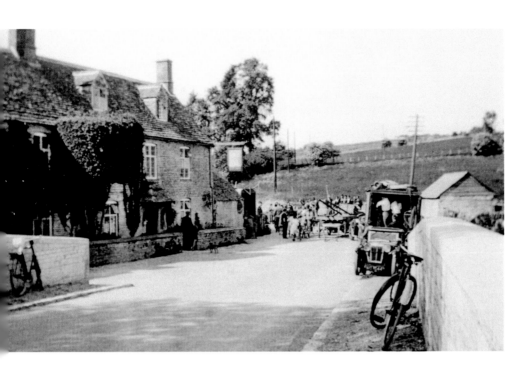

Swinbrook: Filming at the Swan Inn

Swinbrook was the home of the Fettiplaces, an important gentry family. The last male Fettiplace died childless in 1743, but the extinct Fettiplaces are commemorated by monuments in the parish church, which depict them as reclining knights. In 1934 *Lilies of the Field*, a film starring Winifred Hotter as 'Betty Beverley' and Anthony Bushnell as 'Guy Mallory' was filmed in Swinbrook; the upper photograph shows filming in progress. The colour view reveals that little has changed in seventy-eight years.

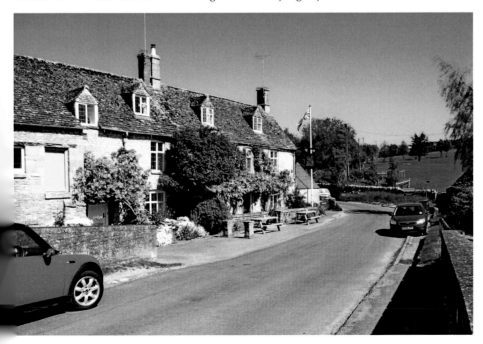

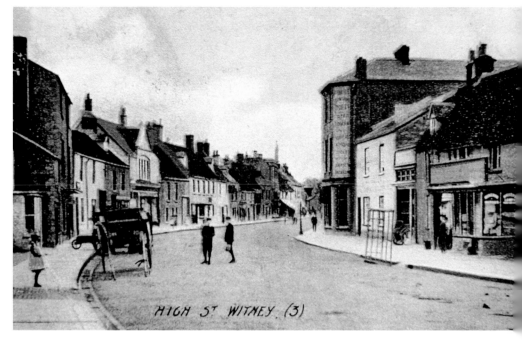

HIGH ST WITNEY (3)

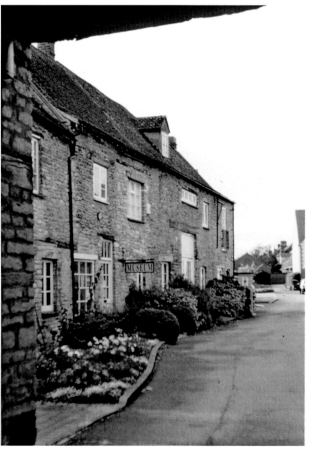

Witney: Old Buildings in High Street

Like Woodstock, Witney consists of a medieval 'new town' and an earlier village settlement. The original village was sited in the vicinity of Corn Street, while the new town, which was aligned from north-to-south, became the present High Street, Market Square and Church Green. Despite modern redevelopment, the town still contains many old buildings. This hand-tinted postcard view (above) depicts the northern end of the High Street *c.* 1912, while the lower view shows the Witney & District Museum in Bartlett's Yard, at the rear of 75 High Street. Many of the archive photographs that appear in this book were obtained from the museum's extensive photograph collections. Further information about Witney can be found in *Witney Through Time*, by Stanley C. Jenkins.

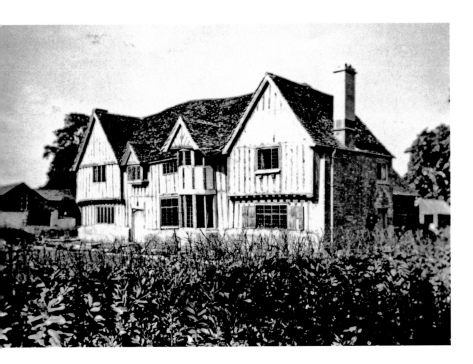

·lford Church & Manor House

ie Domesday Book suggests that Yelford was a small village, with a population of around ‑ty. The village became depopulated during the medieval period, leaving the church, farm ıd manor house as an isolated group of buildings. The manor house, one of the few large nber-framed houses in West Oxfordshire, was the ancestral home of Warren Hastings 732–1818), India's first Governor-General, while the diminutive church, dedicated to St icholas & St Swithun, consists of a nave and chancel, together with a projecting porch.

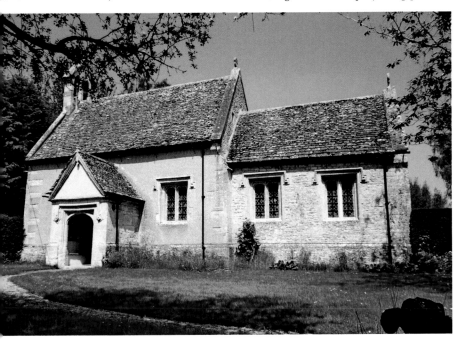

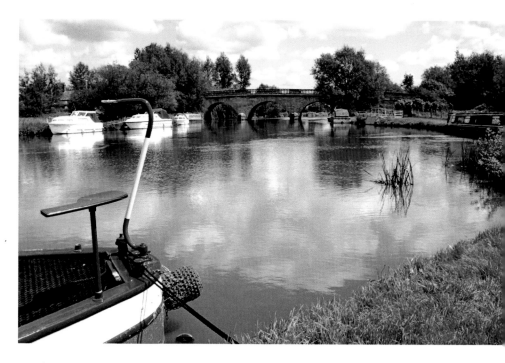

Envoi

Two final views of the West Oxfordshire Cotswolds; the upper view is looking eastwards along the River Thames at Eynsham with Swinford Bridge in the background, while the lower view shows the Church of St Nicholas at Astall.

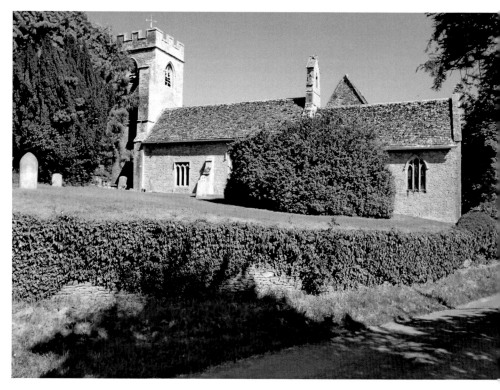